Force

Force

Dynamic Life Drawing for Animators

Michael D. Mattesi

Visit www.enterartacad.com to view
Entertainment Art Academy
with its classes and products
on the cutting edge of education
for entertainment.
Visit www.drawingforce.com to view
online tutorials about Force.

Focal Press
Taylor & Francis Group

NEW YORK AND LONDON

First published 2006
by Focal Press
70 Blanchard Road, Suite 402, Burlington, MA 01803

and by Focal Press
2 Park Square, Milton Park, Abingdon, Oxon OX14 4RN

Focal Press is an imprint of the Taylor & Francis Group, an informa business

Library of Congress Cataloging-in-Publication Data
Mattesi, Michael D.
 Force : the key to capturing life through drawing / Michael D. Mattesi. — 2nd ed.
 p. cm.
 Includes bibliographical references and index.
 ISBN-13: 978-0-240-80845-1 (pbk. : alk. paper)
 ISBN-10: 0-240-80845-2 (pbk. : alk. paper) 1. Figure drawing — Technique. 2. Force and energy — Miscellanea. I. Title
 NC765.M377 2006
 741.01'8 — dc22

 2006018767

ISBN 13: 978-0-240-80845-1

I dedicate this book to my two wonderful children, Makenna and Marin. "Nothing makes me happier than sharing this life with you."

Preface

This book will enlighten you on how to see and explore the power of force through drawing. You will draw with thought and opinions that will strengthen your originality and decisiveness. This will also develop your awareness of the stories our bodies communicate, through the actions we perform.

The theory of force allows you to see in more abstract terms. Because of this, you can apply it to an unlimited amount of applications. It can be used for drawing, painting, sculpting, animation, architecture, graphic design, and all other disciplines of art. It can create a new awareness in your day-to-day life. How are forces operating when you stand, walk, or drive? This book is here for you to understand how to communicate force through drawing, and that is very exciting!

"Art does not reproduce the visible; rather, it makes visible."
Paul Klee

Students who open themselves up to learning are the ones that move ahead quickly. Take what you understand and agree with and use it to further yourself. Some students will actually argue their habits or limitations.

"Argue for your limitations, and sure enough, they're yours."
Richard Bach

These students move nowhere in their minds for sometimes a month, a semester, or even a whole year. Don't waste your time with bad habits! Seek to understand! If you keep doing what you know now, you will keep getting the same results.

Before starting on the journey ahead, I want to give you some of my key concepts.

Key Concepts

HUMANITY

In my last few years of educating, I have had the epiphany of focusing on humanity in drawing. I have taught and lectured in many schools around the world and the one element I see missing is humanity. Almost all art instruction with a figure model is used to learn how to draw instead of experiencing the richness of humanity. Once you have a bigger purpose to drawing than learning how to draw, you will learn faster. You will be more eager to understand, force, perspective, anatomy, and everything else that goes into becoming a great draftsman!

Where does all of this start? It starts with you and your humanity. Become hyper sensitive and present, live in the moment. When you drive, feel the speed of the car, the weight of your body in the seat, inertia and the tension in the steering wheel. What happens to your body's weight when you go into a curve at fifty miles an hour? Don't talk on the phone, eat or listen to the radio while driving. Drive your car. When you eat or drink, feel the food in your mouth, taste it, experience your body swallowing the food and the sensations that occur while it travels down your throat into your stomach.

When drawing the model, stay present and in utter awe! When he or she takes the stand, it is as if they are a god or goddess presented to us. They represent you and the rest of humanity. Become amazed and stay open to this fantastic occurrence. Your experience with the model is your drawing. Therefore, the more rich, incredible, and dramatic your experience, the more rich, incredible, and dramatic your drawing. You are the vehicle to this journey so if you are closed and fearful, so is your work. Use the idea of having the richest and most stimulating experience drawing the model's humanity while using your very own as the purpose to drawing. All of the technique throughout the rest of this book is to serve that higher purpose.

What is there to be in awe of? Look at the amount of effort the model gives you. A living, breathing person is in front of you. Notice their lungs fill with oxygen and how they present you with stress, tension and torque. Look at their muscles and bones perform these great moments. This particular person chooses particular poses. Be sensitive to that. Are the poses poetic, athletic, romantic, relaxed, masculine or feminine? What stories does your humanity find in their poses? You must be sensitive to drama! There is the drama of the pose, the drama of force, the drama of structure, the drama of depth, the drama of shape, and the drama of texture. As you can see, there is plenty of drama and therefore plenty to be in awe of. All of the above is what I refer to as humanity.

TRUTH

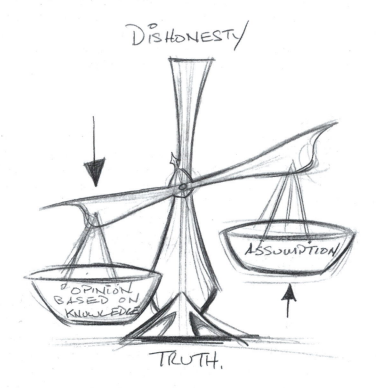

This illustration shows that the increase of opinion based on knowledge brings us closer to the truth and further from dishonesty. You need to gain knowledge to comprehend what to have an opinion about and to obtain the capacity to actualize the opinions you possess upon the page. In this way, your opinion will bring you closer to the model's reality. Every line should have an opinion.

Two ways of clarifying your opinions are through exaggeration and analogy. Making analogies helps you form opinions. "His leg is like a column of strength; the forces are like a roller coaster." I will constantly use analogies throughout this book to make myself clearer to you. If you have something to say, learn how to express it as best you can. Students tell me they are afraid to exaggerate because it is not real. You have a much greater opportunity to capture reality through what you conceive as an exaggeration of ideas than you do working on a dead representation of life via copying. Copying leads to lying.

Push whatever it is the model gives you. Go after its essence. If a pose is about torque, then draw and experience torque. If it is about relaxation, then make it clearly about relaxation. State clearly what you have to say. I love loud drawings, not whispers.

"The work of art is the exaggeration of the idea."
Andre' Gide

Glen Keane is one of today's leading artists when it comes to exaggerating the clarity of a moment. He is extraordinary at giving drawings heart. If something is powerful, you feel its power; if sad, you feel its sadness. His drawings are always loud and opinionated. If you don't know who he is, go see his performances of the main characters in films like The Little Mermaid, Beauty and the Beast, Aladdin, Pocahontas, Tarzan, and recently Treasure Planet, to name a few.

ASSUMPTION

Lightheartedly, one of my first comments to my students is that they are all a bunch of liars. Initially students draw what they think they see and not reality. Not to confuse this with opinion, they create things in their minds that do not exist in the model or the pose the model is taking. Assuming is like guessing. Use this book to help you gain a new awareness of reality. If I create a "force full" drawing, it is because I am aware of the model's forces. You must learn to see by stripping yourself of assumption. I tell students constantly that all of the answers are right in front of them. Open yourself up to the splendor of the life in front of you. There is no reason to lie.

PASSION

You must be passionate and driven to learn and to be great. Love it, hate it, have an emotional experience. Always push yourself to new levels and enjoy the trip. No one strives for mediocrity. Give the drawing everything you've got in the limited amount of time you have with the model. This is the fundamental force behind a student's progression. How can you or an instructor critique your work if it is not your full effort? The critique is then based on only a percent of your ability. You have to believe that you can obtain the goals you are after. In terms of myself, everything I have achieved has been because I knew clearly what I wanted, I intensely wanted it, and some part of me knew I could get it.

FEAR

You are probably wondering how fear would have anything to do with drawing, but it has everything to do with it. Fear kills passion. Fear is the most detrimental attribute a student could have. The greatest fear is the fear of failing which in this case is creating a "bad" drawing. Remember, if you are drawing in order to capture the humanity of the model, you will become unconcerned about your drawing. Be aware of your experience and just stay present with the model. There is no failing, only results. Be courageous and push yourself to new heights. Besides, what is going to happen if you make a "bad" decision? *You will learn from it*. The more results you make, the faster you will reach your destination. It is not as if we are skydiving. You will always land safely, no matter how great the risks you take. Consider yourself the ultimate stunt person.

Pay attention to your internal dialogue. It will reveal your fears.

"Were the diver to think on the jaws of the shark he would never lay hands on the precious pearl."
Sa'di Gulistan

HIERARCHY

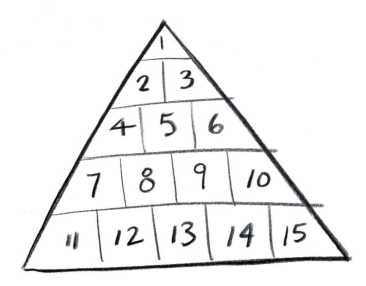

The shape of a pyramid gives us an icon of hierarchy or an order of importance. In the beginning, draw and think with the most important or core idea first; details come last. The pyramid is the human body and the story its posture implies. The top of this pyramid shows the number one. This portrays your first representation of the model. This will be the main idea, or force, of what the model is doing. For instance, standing straight, bending over, seated, etc. Think from large to small. You always want to go after the main idea first. The bottom of the pyramid would be fingernails or something equally insignificant. Many films and books suffer from the lack of this theory. They contain tons of details or special effects, but no heart to the story. What is it about? Don't get caught up in the small things until you first know the main idea.

Animation is also a hierarchical process. Here the entire pyramid symbolizes the character's actions instead of one drawing's forces. The animator's drawings are represented by the pyramid's peak. He draws the key moments of a character's actions. The team of inbetweeners, the rest of the pyramid that works with him, then further develops these motions. Their drawings go in between the key drawings the animator created.

THE ARTISTS AND MODELS

If someone other than myself has accomplished a drawing, I will refer to that artist. Their full names are Mike Roth, MaryEllen Mahar, Keith Wilson, Barrett Benica, and Mike Dougherty. Thank you for all of your help. Every one of you has done a great job! I also want to thank the hard working models that help my students and I recognize the beauty of humanity.

SUPPLIES

I have students in my classes draw on 18"X24" smooth newsprint. Students draw with black china marker or Caran D'Ache. I don't want drawing class to be about fancy mediums. Everyone uses the same supplies. These supplies have been chosen over years of instructing. Newsprint is cheap and the smooth paper with wax is a slick and smooth sensation.

Contents

Chapter 4: Clothing – This chapter will start with the texture of line. Then I will talk about the clothed figure. We will see force's affect on clothing. Also we will learn about how to use clothing to assist us in understanding the pose.

Chapter 5: On Location, Reportage – This chapter is about drawing on location. We go out into the world and "people watch." Let's enjoy the wide variety of characters and real situations that occur every day around us.

Chapter 6: Animals – This chapter is about drawing animals. We start with comparing their anatomies to ours in order to liberate ourselves from anatomical problems. This will aid us in understanding their stories. We talk about the different types of animal anatomy that exist and finding character within our observations.

Chapter 1
Seeing Life

So, what is it that creates life? Force! Force, or energy with purpose, is what we want to recognize in the world around us. I am going to lead you on a force full journey that will change the way you perceive the world you live in. This new perception will clear your mind of the fog of assumption. You will live in a new truth. This in turn will make you appreciate life to a new degree.

Drawing is the profound vehicle for our journey. Through it you will also learn about yourself. Always remember what you put down on the page is a direct reflection of your thoughts and feelings.

There is so much to appreciate and enjoy, so let's get started.

THE AWARENESS OF FORCE

Drawing the body's forces is the least talked about subject in figure drawing classes today, and is yet the most important. The majority of books and instructors teach about copying what you see and not understanding it. I was extremely fortunate to have Jim McMullan as an instructor and close friend at the School of Visual Arts. He taught me to be aware of life in the figure.

The human figure is always full of force – no matter how still it may seem. We are built to move and therefore even when a model is standing straight, there are forces to comprehend and address. We are always under the influence of gravity, which is an all-encompassing force to recognize. When drawing, we need to think about the beauty of why and how the model works, not worry what angle to hold a pencil at in order to shade appropriately.

"Thinking is the hardest work there is, which is the probable reason why so few engage in it."
Henry Ford

You want to draw what you know and empathize with. Draw with the mind's eye, not only your vision. If you find you are having a hard time figuring out what is happening in a pose, then assume the pose yourself. This will definitely help your awareness of force. We are all people. If a model takes a pose that radiates joy and you copy that pose physically yourself (all the way down to the facial expression), you will begin to feel what the model is feeling and know physically what the model is doing. When you see someone who is sad, how is it that you know that person feels that way? As a

fellow human being, you know that you take on the same physiology when you feel sad. You experience empathy through humanity.

Never forget that mind and body are one!

The main idea in the figure

Let's discuss the pyramid of ideas that represent the model's pose. Remember we want to deal with the top of the pyramid, the largest idea, first. You will be creating some general statements about the figure. They will be the first step on your road to understanding force. With experience you will become more specific.

An exercise I do in class is to have the model pose for five minutes. For the first minute, I have the students write what their goals are going to be in drawing the model. I have them list the goals in a hierarchal manner. Then, for the last four minutes, they draw the model and achieve the goals they have written.

Directional force: a beginning, middle, and end

Using the comparison of a writer to an artist, to express our ideas we must understand our drawn language via its own vocabulary. The more vast our vocabulary, the clearer, more intelligent, and expressive our thoughts. There are no great writers without the knowledge to write.

Our language throughout this book is drawing and our understanding of line is our control of that language. The strength of line is immeasurable. To harness its power, though, one must understand how to see force. Draw the verbs of the figure. This is where we want to direct our concentration. Draw what the body is doing, not just the body. While having an internal dialog, think "the stretching arm or thrusting hip," not "the arm is here and it's this thick and look at the shadow on it." Verbs come first and then the noun it is affecting. I will have students bring in a thesaurus to increase their vocabulary and thus their experience of the model.

As important as line is, remember that the drawings are not about line. They are about ideas. The line is your idea. Don't do a drawing for the sake of beautiful lines. Create a drawing that expresses your experience.

Here is the type of line that most describes force in the body.

One line per energy or idea

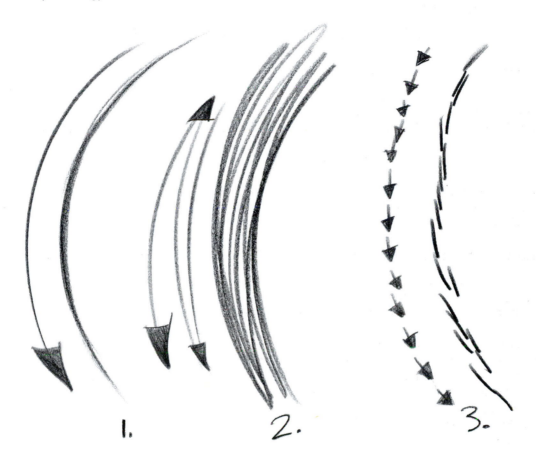

1. Here is our curved line with force and direction. The one line addresses one idea. The line starts somewhere, does something, and goes somewhere. This is achieved with a confident stroking of the paper with the pencil. The arrow example shows you the direction of the energy or its path. This is *directional force*.

2. This is our first student habit. It is sketchy and created by backward and forward motion. No direction. The line, or more importantly, its idea, does not start somewhere, have a purpose, and go somewhere. There is no clear idea.

3. This is the infamous hairy line. Uncertainty takes us from one place to another through thousands of minuscule thoughts instead of drawing one line per idea. Doing this never gives you the opportunity to move onto bigger issues or feel force and direction in your hand and mind.

Forewarning: Don't think that I am talking about being uptight with the line. You don't have to get it right the first time. Let your hand sweep over the paper's surface in the directions the model is moving until you have absorbed the pose's idea. Then start making your marks by slowly applying

pressure to the paper with the pencil while you are still in motion. Notice how you can control the line's value. This discipline of mark making is of tremendous value because when you draw, your head will already be thinking about where energy is coming from, what it is doing, and where it is going. Feel liberated and excited, and be courageous.

Skating the page

An excellent way to get the physical sensation of force is to close your eyes and skate the page with your drawing utensil. Imagine your speed across the smooth, hard, and cold ice. Feel the blades carve deep as you dig into a curve. Your mark on the page should get heavier as this happens. Notice how fluidly you move. There are no clumsy, pinched moments.

Draw small, think big

A great tactic for understanding hierarchy is to draw small. That will help you think about the big picture. This helps you see the body as one story. It is your time to think and it also helps liberate you from feeling committed to your drawing. It's great to draw and redraw that main idea. Draw small and think big. The down side to this is that you stay distanced from the model emotionally. The ultimate scenario is to fill the page with the model's full figure.

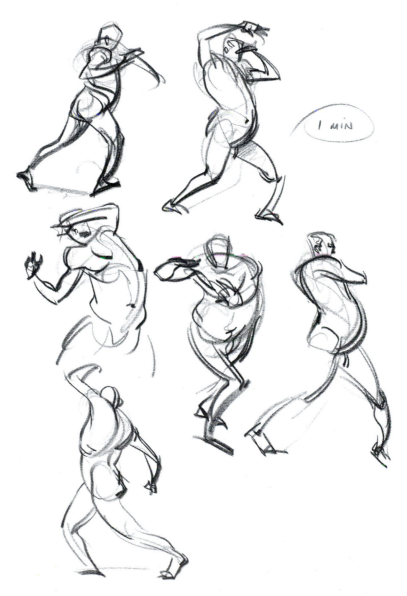

Here are some small one-minute drawings that show the story of each pose.

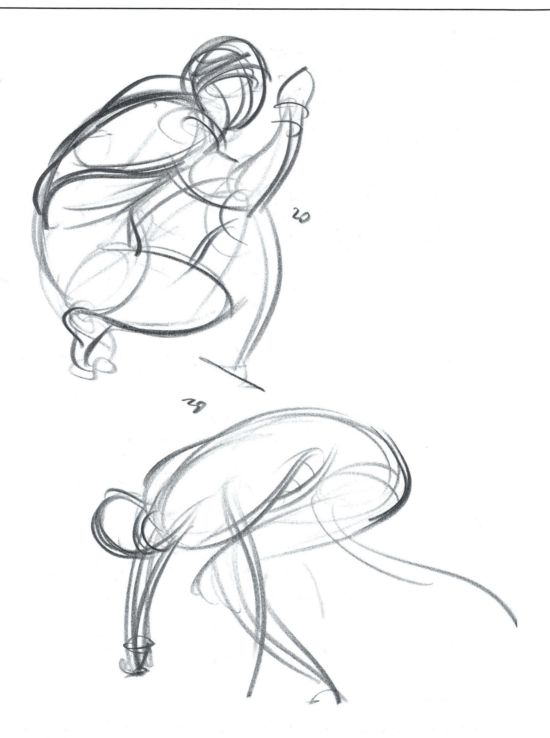

Here are half-minute drawings. The body's entire pose is the key to understanding it.

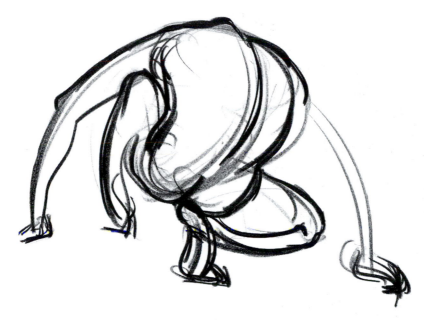

So this pose reminded me of a monkey and that was my bigger thought as I attempted getting the full figure's idea on the page. See the simple curves of force in the back and arms.

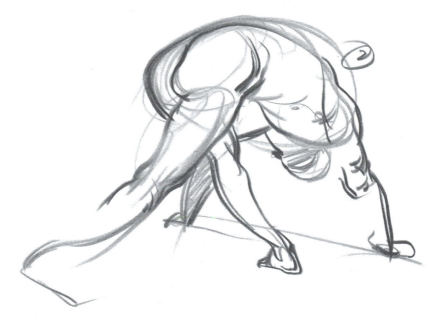

This two minute shows the big picture. With more time, more information was added. Here we have much more structure.

If you are having a hard time finding a directional force curve, try drawing two curves that are opposite each other, one convex and one concave, to see which resembles the figure's main force the most. One of the curves will fit into the puzzle in front of you and the other will be opposing the model's movement. They are generic now, but this will give you an introduction to force. These drawings are usually done in thirty seconds to five minutes. The first force you should look for is the one that tells us the idea behind the connection between the ribcage and the pelvis. Here are some fast drawings to show you my initial reaction to the model's movements.

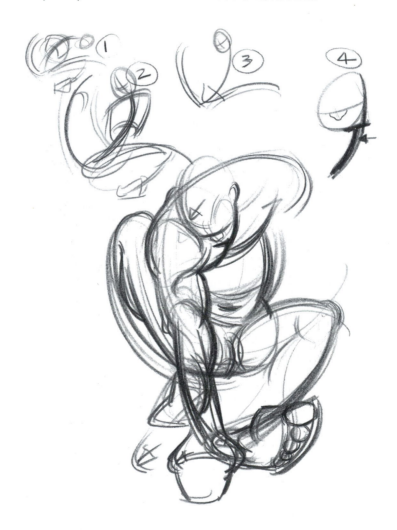

See the power of the directional curves. I do a great deal of drawing through the model to understand where forces begin and end. Above the main drawing are simplifications of the pose using curves of force.

1 and 2 are examples of picking a curve for the direction of the upper body.

See how drawing 2 works because the model is obviously moving towards his right knee. Draw 3 is the same as 2.

4 was to show an awareness of tangents, a topic I will cover in more detail later. This is a close-up of the model's jaw and center of the chest. These two moments would have been flattened if the two ideas were drawn with one line.

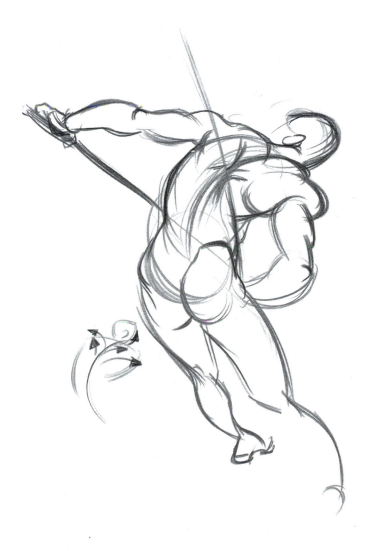

This drawing by Barrett captures the vigor of the pose. The cumulative energy of the back sweeps up into the musculature of the upper body and disperses to the arms and head. It's like shooting fireworks, as the thumbnail shows.

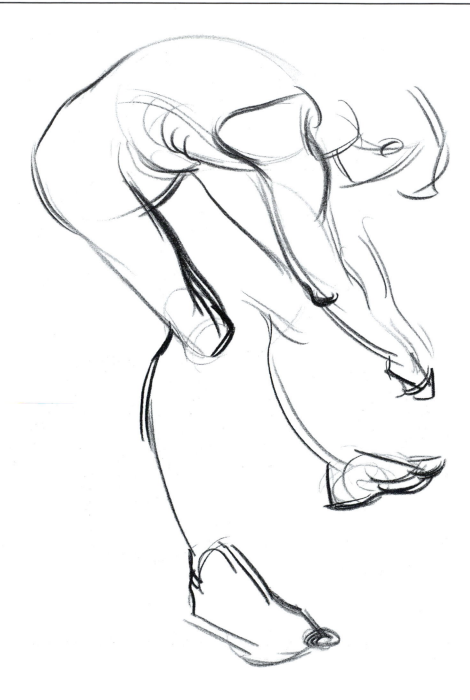

The model has a pull from his hands up through his back and down into his feet. The focal point of force here, or the apex of the directional curve, is the lower back. If the model were to let go, this is the direction he would fall in.

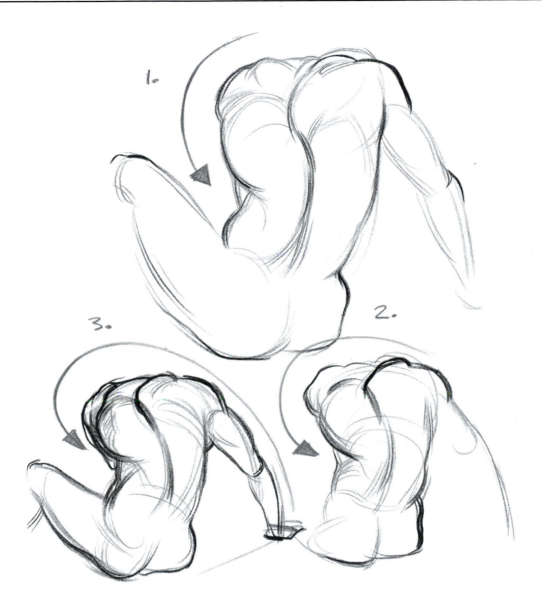

I am so happy I went through many attempts to understand this pose. Look at these drawings in the order they are numbered.

In drawing 1. we have the beginning of force in the left side of the model's upper back. I was dissatisfied with the mediocrity of this drawing. The model was so much more alive and aggressive than my weak depiction of him. Also, the motivation for the push in the back begins at the right deltoid.

In drawing 2. the directional force is more aggressive. Its curve is stronger. There is more thrust into the left side of the back and here we witness more reaction of this force in the remainder of the back's musculature.

Finally, in my third venture, the main idea has extended much further. Now we see that the pose is about the inward thrust of the lower ribcage against the upward energy in the right arm. This combination of forces is what creates the strain in the upper back and pushes the left shoulder out. This page is a great example of:

1. Investigating a pose to gain understanding.

2. Searching for how far a force travels and its true motivation.

3. Not settling for the first attempt. Keep working at a drawing until it feels like the model's effort. It is easy to obtain mediocrity and challenging to stare into the visage of splendor.

"I am not discouraged, because every wrong attempt discarded is another step forward."

Thomas Edison

Applied force

Besides the line giving us a linear direction or path of force, it also tells us how much force is being applied upon it. This is extremely important because the force applied upon the line will be a previous directional force. That previous directional force dictates how strong the applied force is.

These concepts are proven to us in everyday reality through physics. If these lines were roads, you would obviously be able to drive your car through a straightaway faster than you would through a curve. The tighter a curve is, the more you have to decelerate to drive through it. When driving through the curve, the place where you would feel the most amount of force would be at its apex. The force would diminish as you pulled out of it, allowing you to gain speed. Let's look at this in line.

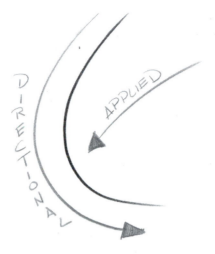

The drawing above presents us with a line that starts with much speed (by its straightness) and then slows through the curve. We also see that the line shows us a mass that is bottom heavy because of where the apex of the curve is located on the line. The attitude or direction of the mass is pushing in the direction of the gray arrow on the right, which represents applied force. Now, if we look at both of the arrows, we get a sense of purpose from the line that takes the mass down and to the left and then directs us to the right.

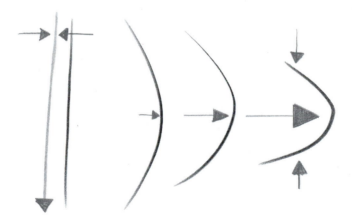

In talking about the amount of force being applied upon a line, we can use the analogy of a flexible metal bar. The curvature of a line tells us how much force it is revealing to us. The line on the left is stretched between two points and shows us speed. The line on the far right has the most amount of force applied to it because of how strong its curvature is. In animation terms, it is "squashed," which tells us that there is force pushing on it from above and below. The mass being pushed on is thrusting out, shown to us by the curve. This curved directional force is also slower than the first force.

Curved lines are more forceful than straights since they clearly show us directional and applied forces.

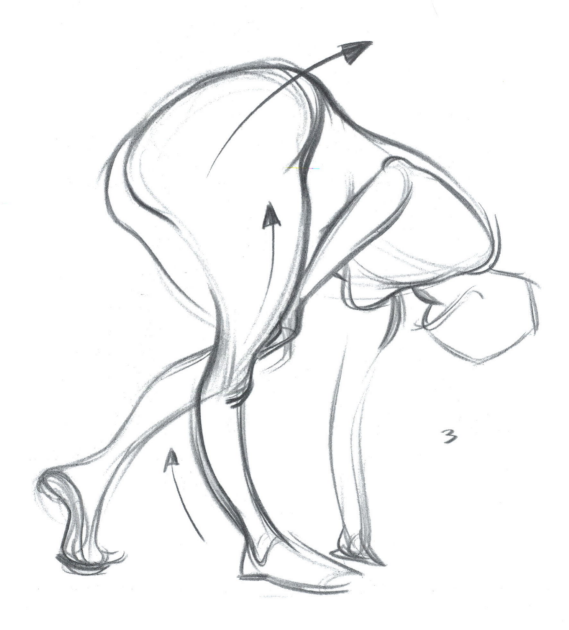

Here is a clear example of applied force. Look at how strongly it is pushing up into the hip. I also described the rhythm of the right leg shooting up into that hip.

In this drawing, the model's left shoulder is an obvious apex of applied force. Look at how it fluidly connects to the direction of the neck.

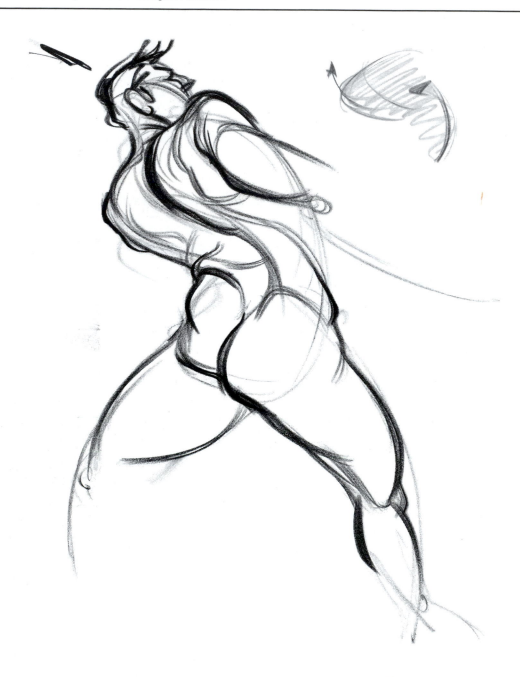

In this drawing by Mike D., you can see directional force apply itself into the model's left shoulder and back.

The leading edge

The leading edge is the edge of the body that leads a motion. This is where the largest amount of applied force can be found. A past force that directs itself to this moment in the body creates it. To help students understand this idea, I describe it as the bow of a ship or a catch of force. A simple way of finding this is to watch the model go through a movement. The direction of his or her motion gives you the answers.

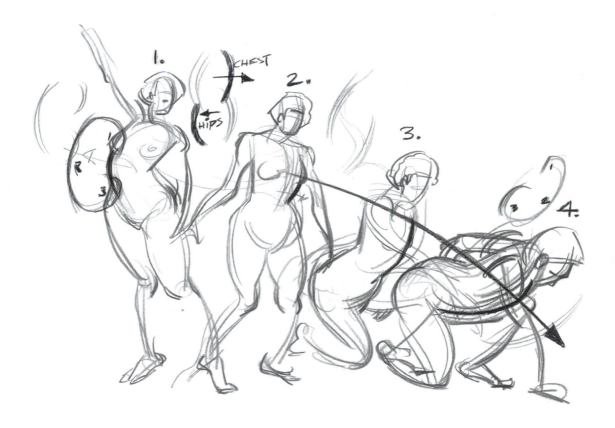

In these drawings, see how the leading edge is the ribcage. In drawing 1. the ribcage directs us to the left, as the head looks right. The model's upper body turns in the direction of the head in drawing 2. When it does everything follows it. The arrow from 2. through 4. represents the direction of applied force that creates the strengthened curve of the ribcage.

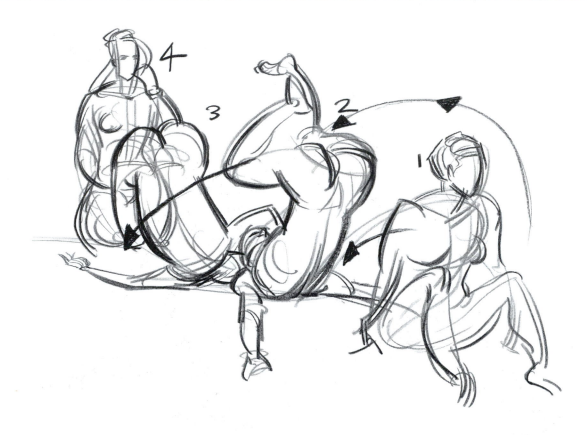

This was an adventurous and daring motion. The model executed a backward roll on the platform! At 1 the leading edge is her upper back. It initiates the drive down to the platform. At 2 her legs become the leading edge. They help continue the momentum over her upper body and get us into 3. Here her right knee brings us down to the platform and the ribcage shows what direction (from left to right) she rolls in. Then finally in 4 her upper back returns her to the seated position.

The following drawings are the model standing still. Nonetheless, we want to see movement. Pay attention to he or she getting into the pose to help recognize the leading edge of applied force. The repetitive lines in some of the drawings show also the direction the model would have moved in. I have drawn thumbnails to show you what my approach was on these poses. Enjoy the energy.

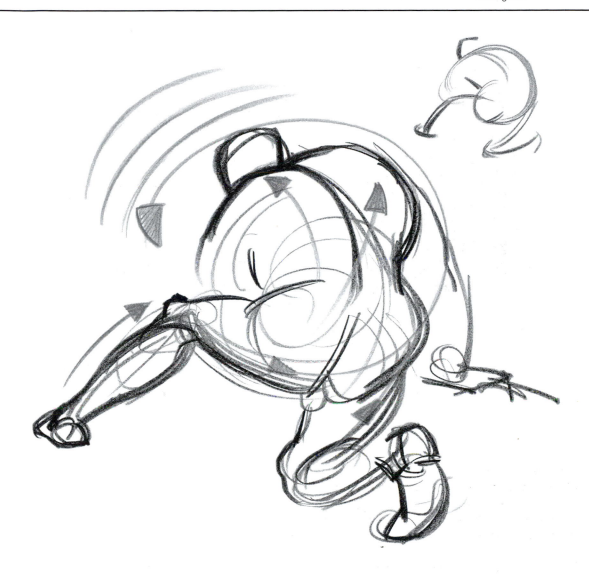

The model here takes an aggressive counter clockwise rotation. His left leg is the brace for this motion. Applied force is constantly pushing against the directional curve. The leading edge is where you see the repetitive lines above his left shoulder. Think of this concept as deciding where the model is going.

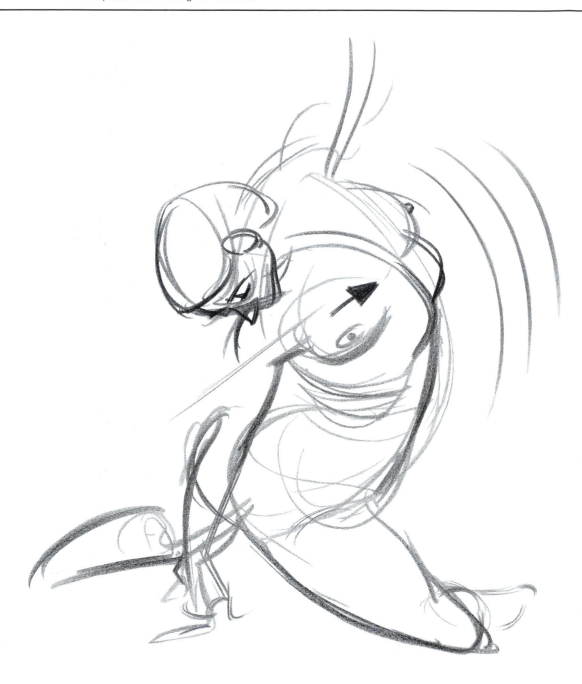

I love the upward rotational thrust into her ribcage. Again, the leading edge is the place with the three lines. It feels as if she would push herself forward to continue the motion of the pose. The applied force found here originates in the hips.

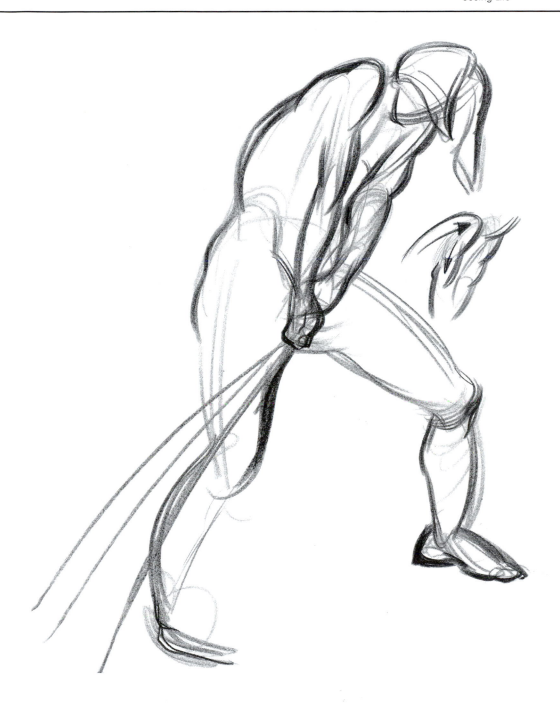

It is obvious here how much applied force there is in the model's shoulders. See the strength of the curve. Here is our catch or ship's bow from all of the force she is using to pull back on the rope. This is also the peak of our leading edge. She would continue this pose in the direction of her shoulder.

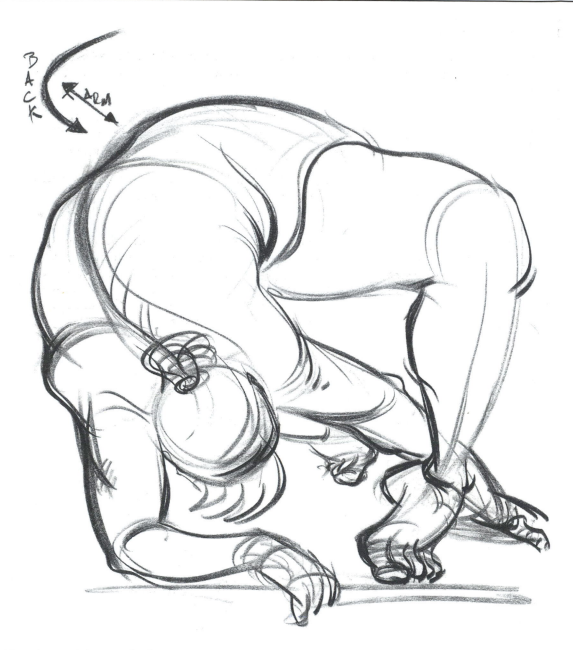

Here the model's stretched arm acts like the arrow that relates directly to the applied force and leading edge of the back.

In the first half of this chapter, we discussed directional and applied force. Now we will see how the union of the two creates rhythm and harmony.

THE ROAD OF RHYTHM

A rhythm is the beautiful and seamless interplay of different forces in the body that helps it stay in balance, or creates equilibrium. Rhythm exists in all living things. Your understanding of rhythm will help you create living drawings.

Gravity is the reason we have rhythmic balance in our bodies. Our anatomy is not linear but asymmetrical in its musculature. This allows us motion against the force of gravity and equalization when standing still. Understand this will help you draw a living, grounded, balanced figure.

> "The aim of every artist is to arrest motion, which is life, by artificial means and hold it fixed so that a hundred years later, when a stranger looks at it, it moves again since it is life."
>
> William Faulkner

One line or idea is a force; two forces create rhythm. To draw rhythm, we must understand the relationship between two directional forces or ideas. The attitude or direction of one line or force will apply itself towards the next. In the first part of this chapter, we discussed directional and applied force. The applied force is actually part of the body's rhythm. It is the result of an earlier directional force. Energy is coming from somewhere and sweeping into the main idea of the pose. Some students understand this better as action, reaction, or moments of pressure.

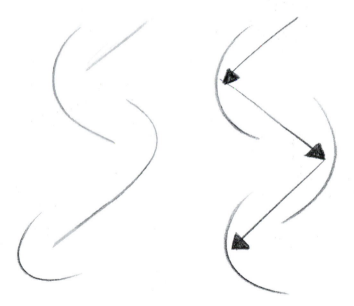

In the drawing on the left, notice at the top we begin the same way we did in our description of applied force. On the right, we see applied force represented by the arrows pushing into directional force drawn in curves. The directional force then directs us to another place in the body. The directional force becomes applied force. When this energy hits its next exchange and needs to be redirected, it hits a new directional force and then turns into an applied force once more.

Be aware of the angles of the body. The drawing on the right shows you how they are created by the forces. See how angles allow you to stop straightening out the pose. This is a bad student habit. Angles are exciting and you want to find them. Try to avoid horizontal and vertical moments. The forty-five degree angle is the most aggressive. Do not draw the figure with straight lines as we discussed earlier.

Since rhythm is at least a pair of forces, you will get closer to the top of the pyramid by taking two ideas and turning them into one. Another way of combining is to be aware of the relationship between the arms, legs, and both sets of limbs to one another. The most expansive relationship is between the head and the feet.

Let's use the analogy of skiing slalom. Before us we have gates we must go through. These gates represent the apexes of our directional lines of force or where applied energy in the model is the strongest. There is a most efficient way to ski from one gate to another and the bouncing effect created in doing so feels like drawing rhythm. As seen in drawing 1, the more close the gates are in distance going downhill, and the further apart they are from left to right, the slower we will have to go through them. The closer they are to being a straight line, the faster we can go through them, like the example in drawing 2. Gravity is what continuously pulls us through the gates. A certain fluidity is obtained in skiing through the gates, along with a certain rhythm.

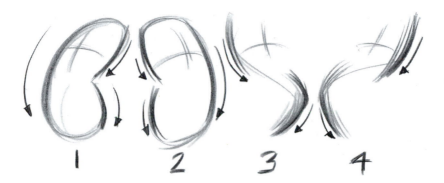

1 2 3 4

Here are four basic set-ups for the ribcage to hip relationship. The crosshairs represent the center of the chest. This is the top of the pyramid. These are some generic ideas because we all have the same anatomy. These concepts represent the front and/or back of the figure in rhythm. Always try to find one of the four.

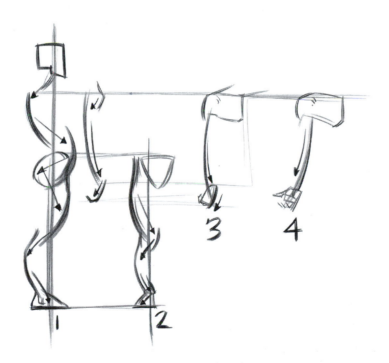

Here is the general set-up for the side view of the figure. Notice how rhythm goes from one side of the figure to the other to obtain balance. In figure 1, look at how I draw through the crotch to get to the butt and up into the hips. Then we shoot down the thigh. Drawing 2 shows the rhythm of the leg from the front and the back. Drawings 3 and 4 are the arm from front to back. All of these diagrams are generalizations. These will work almost all of the time but there are instances where the rules will be broken, fortunately. Look for idiosyncrasies.

These examples show two common errors that students may make after an initial discussion about rhythm. On the left, what we see is that the student has put the same kind of force on both sides of whatever part of the body this represents. The body will almost never be the same on two sides. Rhythm must be oblique to create balance. In the case of the left and right side of the trunk of the body, it is the front and back that are anatomically oblique. We will go into this further in Chapter 3. Going back to our car analogy, we see here that this is an accident because both forces collide instead of passing force off to one another. You should not worry about encapsulating the figure in the beginning. Draw only the rhythms of the body.

On the right is the spaghetti line. Some students will do this as an attempt at connectiveness and mass but lose energy in doing so. This line has many energies with no obvious transfer of force. The line does not start somewhere, do something, and go somewhere. Every arrow represents what should be another force or idea. Energy needs to be passed from one place to another.

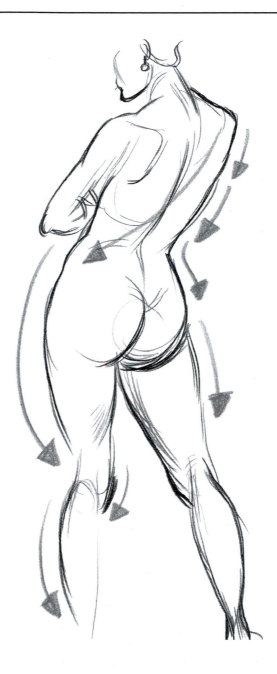

I have taken one of my drawings to show you an example of this. If we start at the top right shoulder, once we get down to the lower back we should not continue over the right buttock. Rhythm is not about following the edge of the model. This would put the model off balance. Notice inside the model how the arrow takes us from the right shoulder to the left hip. This is our applied force. It is what pushes out the left hip.

Through following rhythms in the figure, you can get a quick understanding of the entire pose's purpose and balance. The relationships of different forces in the body will become broader in concept. Remember, your main objective is to draw what the model is doing, main idea first. There will almost always be a relationship between the torso, hips, and head. In animation, you want to animate the primary source of purpose creating action. This is usually the head and trunk of the body. The limbs follow and assist the idea.

Beyond the head, ribcage, and pelvis, you want to draw these lines of force from joint to joint in the figure. For instance, connect the hip to the knee or the shoulder to the elbow. This will stop you from drawing hairy lines or broken ideas. Again, if you are having a problem seeing the forceful curve, draw opposing curves and see which most resembles the movement of that particular part of the body. In time you will understand the operation of a whole limb, like the wrist to the shoulder.

When animating, or drawing, gravity is the invisible force you must always be aware of to bring reality to your work. Some pointers to think about when drawing the figure and considering our topic:

1. A man's center of gravity is in his chest, a woman's closer to her pelvis. Women in general are better balanced because of their lower center of gravity.

2. Always pay attention to where the model's head and center of gravity are in comparison to his or her feet.

3. Think about the model's mass and forces and realize they have to be equalized on both sides of the centerline of balance in order for the model to stand. This does not have to occur when someone is moving. Then the body has time to compensate for its lack of balance.

4. Notice the implications of gravity pulling on the model, squash in the feet, muscles working with and against it.

5. When drawing the amount of pressure in the model's feet, take into consideration the weight of the model.

Now, once more, let's go to drawing small and thinking big.

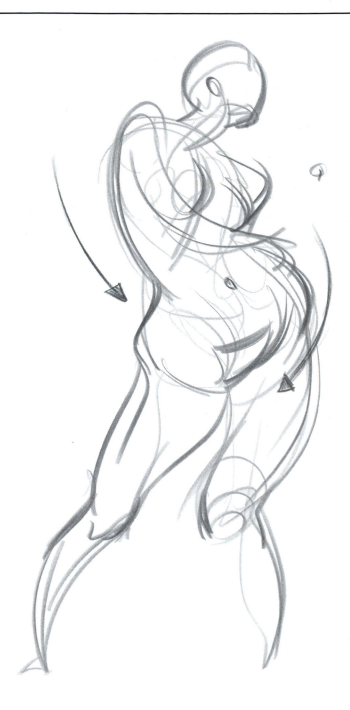

This is a four minute with the model. Again, see that the focus is on getting the main forces of the model and how they relate to one another. Look at how the weight and force of the ribcage sweeps down into the hips.

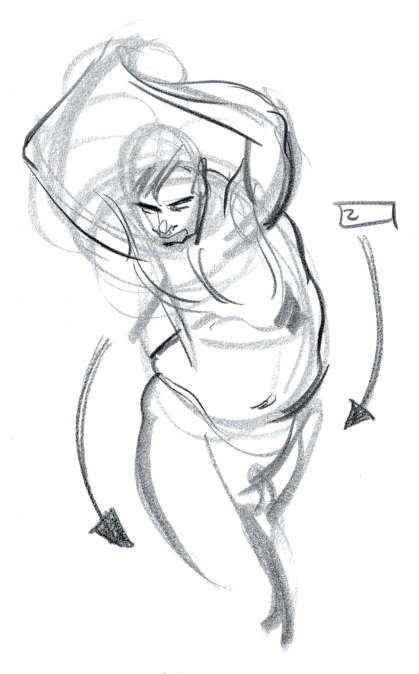

This drawing shows the first big rhythm to find, the top of the pyramid, the ribcage to hip relationship.

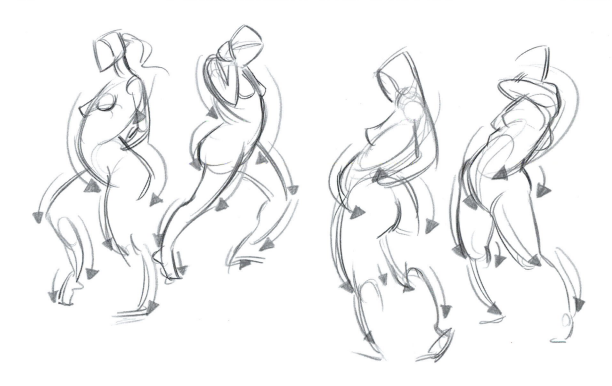

Looking at these four drawings, there are many patterns one can see. Notice the constant attention to the relationship between the ribcage and pelvis. The buttocks represent the pelvis. In most cases you can see the force of the thigh pushing the knee and calf back. Look at the close resemblance to the skiing analogy.

The road of rhythm is the figure's solution for balance. You must first find this road and draw the moments along the way. Your initial recordings of the pose should not involve you teleporting from one area to another in the figure without understanding the body's connections. Only draw the parts of the body you travel to through rhythm. This makes the drawing's sense of balance clear.

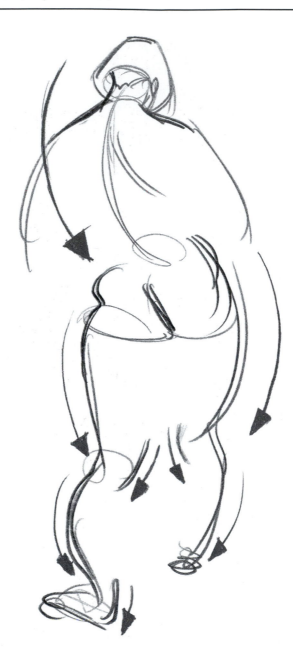

Rhythm in this drawing is obvious. (It is the only parts of the model I have addressed.) So little is actually drawn yet so much is said about the essence of the pose. Once we sweep into the hips, force divides down each leg. See the importance of the knees as a place for the transfer of force between the upper and lower leg.

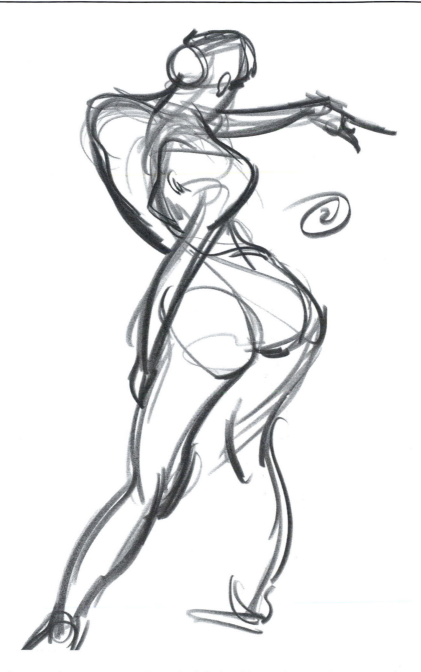

This drawing shows a clear asymmetry from the left shoulder to the right hip. Notice how we travel in an "inside, outside" pattern from the hip to the heel in the model's legs.

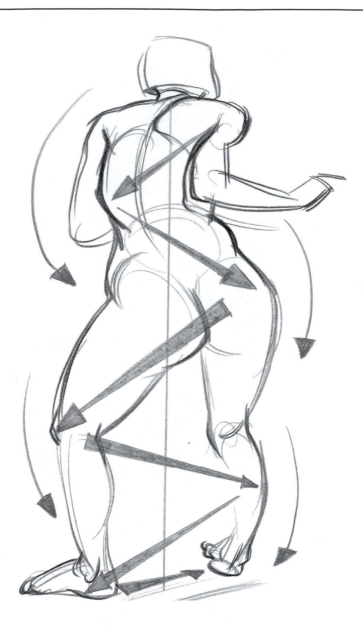

There is a great deal to absorb here, so let's go through this step by step:

1. The applied and directional forces set up the body's cohesiveness or rhythm. All of this happens for the body to stay in balance. This applied force obliquely crosses over the line of balance, equalizing force and weight on both sides of the body.

2. Notice the line of balance. It is a guide of equalization of force and weight of the model. The model's head coincidentally happens to fall on the centerline.

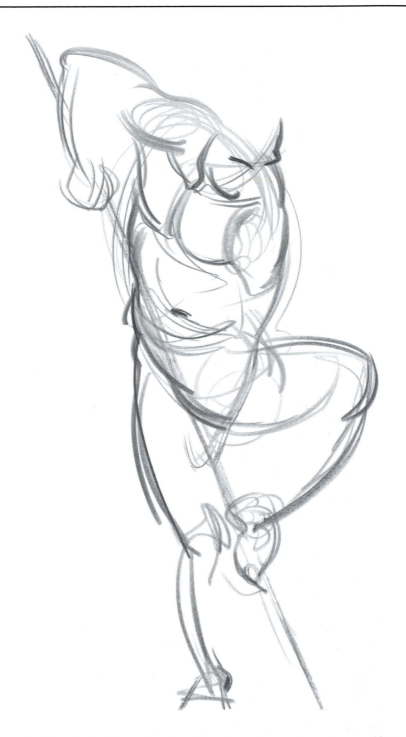

Here I want you to look at rhythm's road and see how it continuously creates equilibrium.

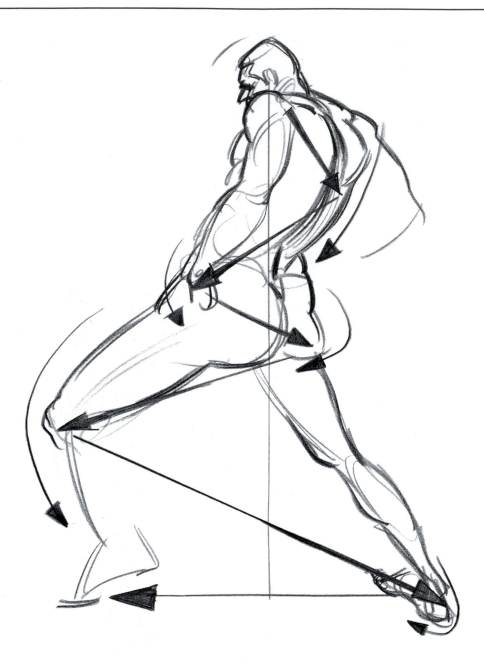

Another blueprint. In order to comprehend the model's balance you must look at the rhythm or relationship of one leg to another instead of only moving down one leg. This is a great example of pairing. Notice again how applied force moves across the line of balance of the figure.

Look at the next few drawings and find the vertical line of balance.

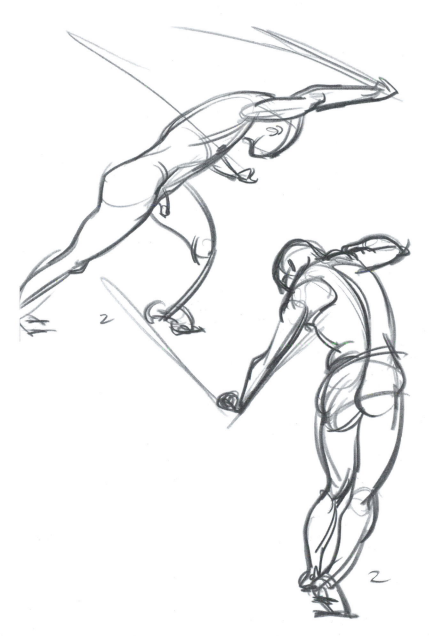

In order to see balance, look at these drawings and understand how the model would fall without the rope he is holding onto. The top drawing shows the center of gravity in his chest way past the platform of his feet. The rope in his hands pulls back over his body to balance his weight. In the next pose, he would fall to the right were it not for the rope's tension on the left side of his body.

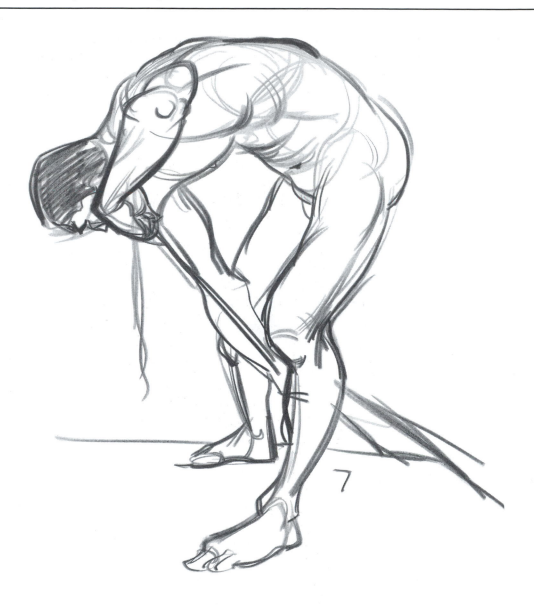

7

Here the model is just slightly assisted by the rope. He would normally be teetering on the balls of his feet because of his chest's placement relative to them. Instead he stands flat-footed since the rope is used like a pendulum.

The head is extremely important because it usually establishes the direction the body is going to move in, like the engine of a train. If you turn, your head initiates that movement. You never turn your body first. It is the control center for the figure's actions. Pay attention to how it affects the body's balance because of this. It is so small in size relative to the figure, though, that for the sake of the pyramid and getting the largest idea on the page first, we go for the ribcage/pelvis relationship.

The head must always coincide with the nature of the back. Many students forget to notice how the head projects out of the ribcage and that the neck does that job. I usually try to use the sterno-cleido-mastoid, or the muscles that run from the back of your ear to the meeting point of the collar bones, as a way of showing the neck's forces.

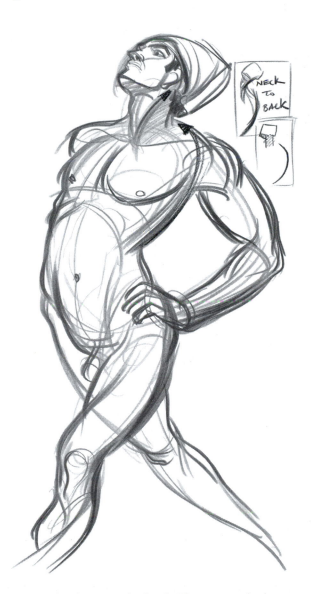

See the opposing force of the neck relative to the back. The sterno-cleido-mastoid shows this with subtlety. I drew a couple of diagrams showing the wrong and right way to handle this relationship. The bottom drawing demonstrates a straight tubular neck with no relationship to the back. The top is correct with its opposing force.

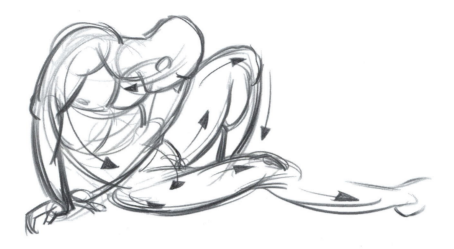

This pose feels fast. Look at the beautiful rhythms. The westward lunge of the back against the eastward projection of the head and legs creates an aggressive angle of balance. Look at the road of rhythm.

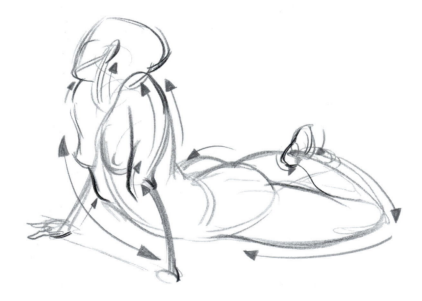

First we have an elongated stretch of the abdomen all the way up to the pit of her neck and down to her hips. All of the weight of the torso that is being suspended by the cradle of the clavicle drives upward from the hands into the shoulders. This is the reason for the stretch. Notice the transfer of force in the elbow. The opposing force of the ribcage is her upper back, which then rhythmically connects us with her neck through the sterno.

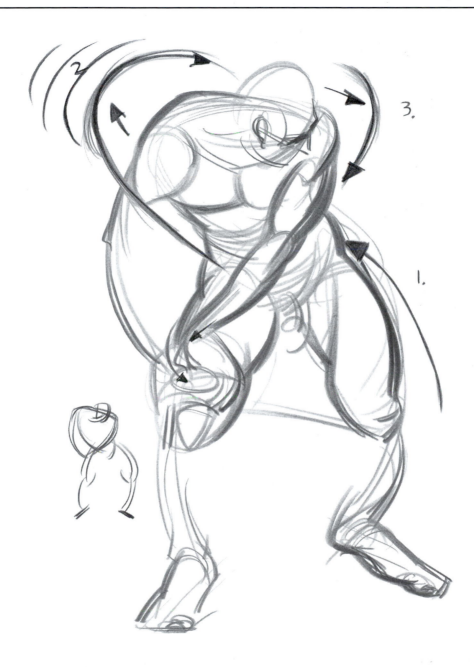

Notice the spatial quality of the long ride of rhythm. At 1., we start way back in the left thigh. We then travel through the body to 2. and dip aggressively down to 3. After the hairpin curve, we shoot down to the hand.

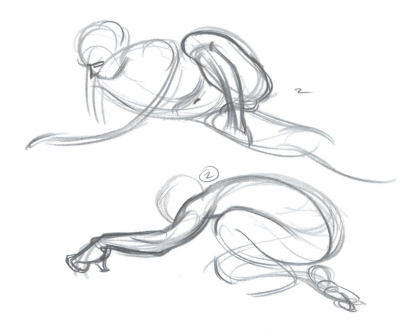

In two minutes, each of the drawings above has the main concept of the pose described. Long fluid lines help describe these ideas.

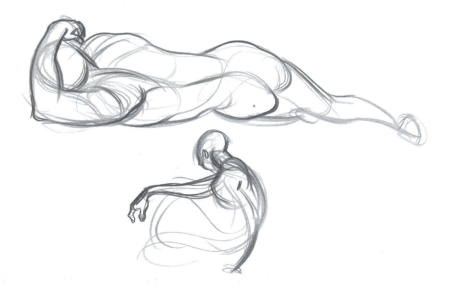

With three extra minutes, you can see how the top drawing has more mass and description of anatomy.

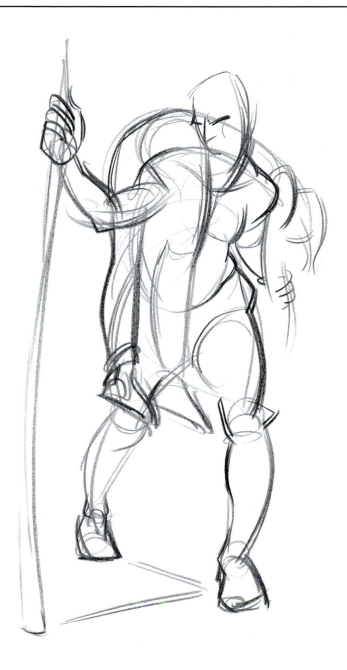

The model did a great job of giving me something new and exciting to understand. He held this fireman's carry pose for five minutes. See the majority of the weight of her body draped over his right shoulder and how he uses the pole as assistance to his balance. Notice the broad base he created with his stance.

THE ROLLER COASTER OF RHYTHM

The road of rhythm is a more flat, two-dimensional, left to right approach to comprehending the fluid-like balance in the body. It is the beginning of something greater. The roller coaster analogy starts using the body's masses to recognize how force moves in a more connective and dimensional manner.

I tell students to imagine the model's platform as the amusement park and the model as the roller coaster. Your first task is to get your mind's eye into the park, close to the model. I suggest to students that they think of themselves as being one inch high. This empowers them to envision the figure as gargantuan. The model's tremendous size guides the students into seeing more roundness and depth. This helps you see just how long an idea goes before it turns into an opposing force because the body's energy changes direction. This again will help you get closer to the top of the pyramid. Beware of drawing the spaghetti line we discussed earlier in the chapter.

You now connect the directional forces to one another and how they are applied. The road of rhythm becomes seamless. To create this seamlessness, you NEED to travel around the forms of the figure.

Next, find the largest moment of force on the roller coaster and hop on. The tracks are smooth and graceful. Feel how they project you through space, over high peaks and low gullies, through fast straight-aways and G-force-filled turns, spiraling along loop-to-loops, and pretzel-like structures. Then time is up, you get off the ride, the model changes positions, and a new and exciting ride is yours to experience.

You have to give yourself the right to draw through the figure. Those of you who are uptight have to loosen up in this exercise. Drawing through the figure will dramatically help you see long and begin to understand space, dimensionality, and structure.

Disney's Fred Moore was one of the best artists at going long with beautiful, rich, fluid ideas. You can see drawings of his in some of the older Disney books.

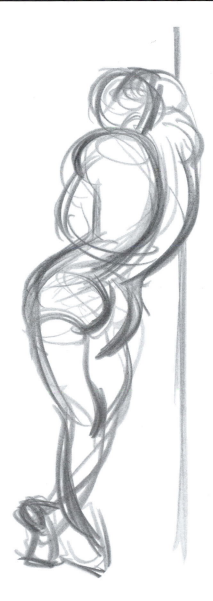

Look at how connected the body's rhythms are. This one-minute drawing shows how much can be said about a pose's energy in very little time.

Students seem to think that they always have to draw an enclosed figure. This is just another habit to hurdle. For now, you want your attention to be on rhythm. Remember it is the essence or main idea that you want to achieve. Fluidity, continuity, action to reaction, and all of the theories I have given you are ways to think about this concept. Use whatever it takes for you to understand this principle. Remember, if you can find but one place in the figure where you feel you understand the forces shown, they will lead you throughout the rest of the pose on the road of rhythm.

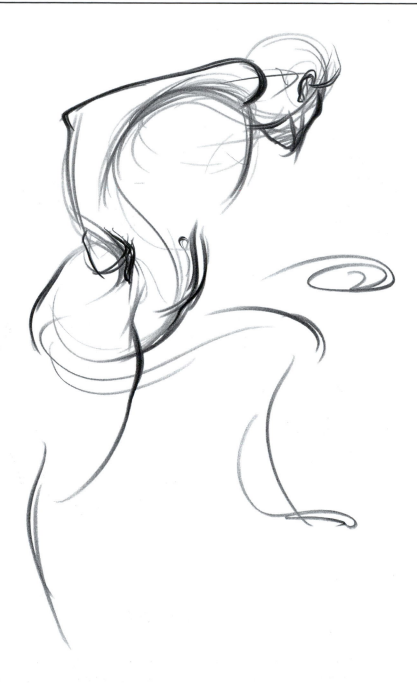

This drawing shows how force directs itself seamlessly from one place to another in the model. Notice that I draw through the right leg to get to the buttocks and the shoot up to the hip. Also see me draw through the right shoulder and over the top of the back to create the rhythm between the upper back and neck.

Here is another drawing that shows force directing itself through the entire body. These drawings show the first steps to drawing force and the most important ones. Line skates the page and moves force. Notice how we can travel from the hand through the entire body to the foot on one connected path.

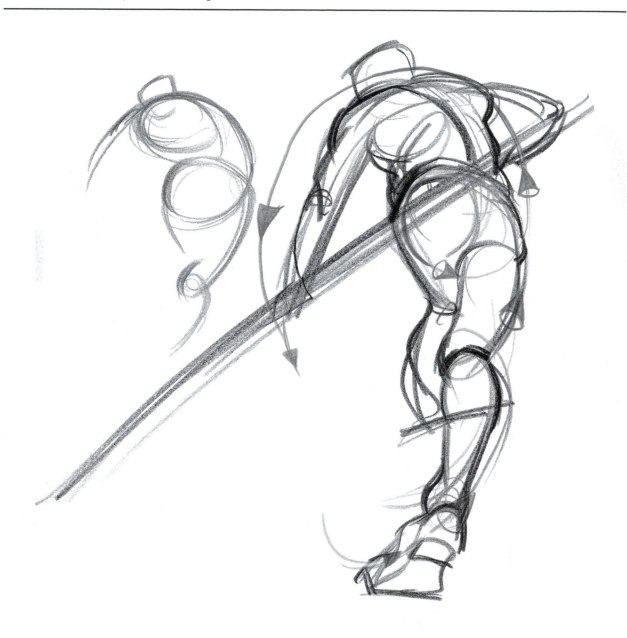

The thumbnail on the left shows you my first thoughts on how to approach this pose. Look at how much is said about it with long ideas.

Here we shoot up the model's right leg, roll around the knee to the forceful side. Then we swing our way up the thigh and over into the hip where we make our final ascent up into the back, over the shoulder, and down into his extended arm. The relationship of the left arm and right foot helps encircle the idea of this pose.

I love this drawing. To me it is so alive that it's musical. The thumbnail on the right shows my initial idea.

Look at the long connection of her head and elbow down through the hips, up through the thigh to the knee. Finally, after that long and elegant journey we have a change in tempo but for a moment, found in the knee. Off we embark down the calf for a fast and graceful curve to her ankle where it repeats the tempo of the knee. Look also at how effectively mass is described with few lines.

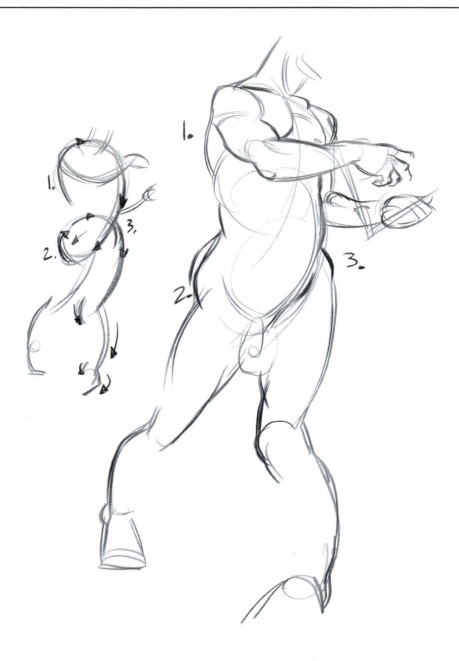

Here we see where some ideas are longer and more connective than others.

1. The upward sweep of the back is where we will begin. This directs us across the body where we travel down to the crotch and sweep up through the left hip at 2. and drive up into the right one at 3. We then pick up speed again and shoot down the thighs through the knees and to the different endings in his feet.

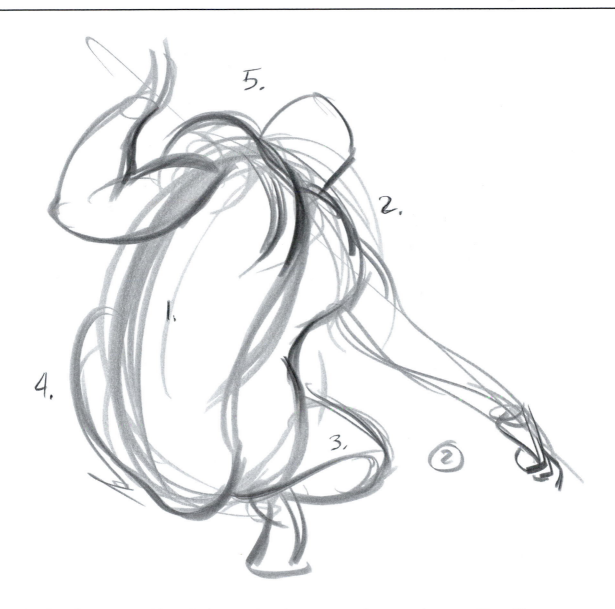

See here how at 1. I address the largest idea, the connection between ribcage and hips. Then, to push the ride, we can sweep into the arms at 2. and 5. We also can glide into the legs at 3. and 4. with seamless rhythm.

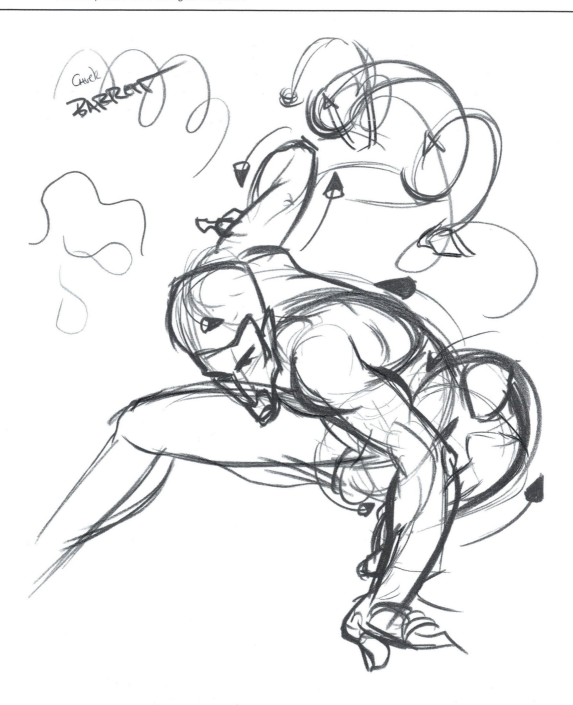

This drawing started off as an exercise where I have students begin a drawing and then another student finishes up the time restriction. This drawing was started by Chuck and then completed by Barrett. Barrett unknowingly succeeded in producing a drawing with a very long idea. Above the

figure you will see my explanation of the roller coaster ride we take. Barrett explained how he was content with seeing the model's left leg from hip to foot as one idea. A second look at the drawing shows us how that force sweeps through the crotch, up and over the back, into the deltoid, and then down to the model's wrist. Remember: Everything in Chapter 1 works together. At times you will see applied force, and sometimes you will see the chance to go long, all within the same pose. Either way, you want your drawing to be a rich experience of the humanity that was in front of you, a loud drawing of your understanding. Don't forget the power of the force full curve.

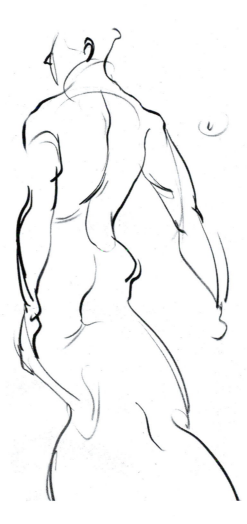

Two minutes of clarity created the last drawing in this chapter presenting the rules of FORCE with efficiency and sophistication. The pose exudes masculinity coupled with feminine grace, a wonderful contrast found in this model.

Now let's look at how to better describe the forms around which force travels.

FORCE POINTERS

1. Skate the page. Close your eyes and imagine the paper as ice and you as the world's best figure skater. You are performing your best routine. As you skate, feel the fluidity and speed of your movement. Notice how the blades cut into the ice as you move through tight and open curves. Your marks should indicate the change in force and pressure that your body would feel on the ice.

2. Find the ribcage to hip relationship first. Keep seeing how their relationship is asymmetrical and falls into one of the four previously discussed scenarios.

3. Stand and mimic the model's pose. Start with the biggest ideas of the pose and work down to the small detail. Close your eyes and feel your body in that pose. Notice the stretches, torques, pressures, and gravity on yourself. Then push the pose and feel where it wants to go. Put those experiences into your drawing.

4. Watch the model move into a pose. Look at the directions their body swept into to take the pose. There lies answers to force.

5. Draw with a clear directional force for each part of the figure.

6. Be passionate about the aliveness of the model and the pose. Draw your excitement.

7. Write what you are achieving in a drawing. Bring a thesaurus to increase your vocabulary about your ideas. Write verb first then noun it affects.

8. Pay attention to your internal dialog. Don't be self defeating.

9. Explain what you see, don't just copy it.

10. Get out of your own way. Don't worry about the drawing.

11. Always have something to say.

12. Draw to feel what the model is feeling.

Chapter 2
Forceful Form

Learning how to draw takes two parts. One part is knowledge about technique. That is perspective, anatomy, force, and shape. The other side of drawing is honest observation, being able to draw what you see. When the two combine, you can draw! You draw what you see and understand it at the same time. You can assess your own experiences and see where you need more technique or more honest observation. Is the drawing generic? Look more. Is it specific but flat, dead, and poorly designed? Use technique.

Every chapter of this book is designed in a hierarchy. We go from big ideas first and then to specifics. In this chapter I will cover many techniques about forceful form. This will lead us to observation of specifics. The largest technical skill to learn when it comes to form is …

PERSPECTIVE: THE DRAMA OF ANGLES

Artists' understanding of the theories of perspective has changed the world we live in. Their observations helped them create dimensional thoughts upon a flat surface. You are affected by this every day of your life. Recognize that the chair you occupy and the space you live in were conceived by an artist with the capacity to draw form.

The first topic we'll cover is perspective. Perspective is not difficult, it just takes some time to understand what you are seeing and know that you are capable of representing depth on the page. This happens after understanding the traditional ways of drawing it. I learned perspective in junior high first, then from "How to Draw Comics the Marvel Way," and then, most importantly, from the four years of architecture I studied in high school. The cube or box is the beginning of understanding structure in space.

One of the major uses of perspective is to show you what angles to draw objects at. These angles give you the sense of vanishing that occurs in our world.

One, two, and three points

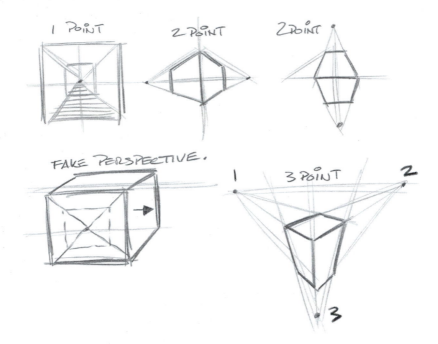

One-point perspective is everyone's beginning when it comes to seeing space into a flat page. It is limited. Its main use is to draw flat planes in depth. In the box on the left, one point shows its limitations. When looking at a box, as soon as we face it from any direction besides head on, we are dealing with two points or more of perspective. We cannot see another side of this box until we have two points as reference.

The box in the bottom left corner is an example of what I receive from students when I ask them to draw a box in perspective. This is the nemesis of perspective. I know we are taught this, but if you look at the box, notice how the front face has right corners all around. We are looking directly at the front face, so how would it be possible for us to see any of the other sides? It is as if we took the back plane of the box and slid it, in a parallel manner, away from its actual structural orientation with the front of the box.

Two-point perspective has the cube converge in perspective on one plane of existence. Notice how the vertical lines in the box are parallel and the others are not. Here our cube is affected only on a horizontal plane. The horizontal lines of the cube are being squeezed into perspective by the vanishing points. As soon as we are above or below the box, which means we should see three of its planes, we must have three points of perspective.

In three points, the box is affected by perspective on two planes, vertical and horizontal. Number 1 and 2 are the horizontal points and number 3 is our one vertical point. We could have two points on a vertical line and one on the horizontal. In this case, the third point gives us a sense that the box is

long vertically. We seem to be floating above it looking down. The vertical lines that create the box are converging downward towards the third point. An easy way to find out how many points a box is affected by is that to find out how many planes you see. They will be the same amount.

Some simple rules to help you become aware of perspective:

1. The left point on the horizon line affects the left plane of the box. The right point affects the right plane.

2. This is inverted when you are inside the box. This comes into play when you do a room interior.

3. When an object is below your eye line, the verticals are affected by the point below your eye line. When the object is above your eye line, the verticals are affected by the point above your eye line.

To help explain one, two, and three points, I am going to use drawings of people's heads. Why? The head is the most block-like structure of the body. Some artists like to construct the head from a ball; I prefer the cube. It is more definitive. It has clear planes that erase doubt as to what specific direction in space a person or animal's head is in. Use the angles of the cube to help define the angles of the facial features. Just as curves defined force in Chapter 1, straight lines evoke structure and perspective.

This drawing is a profile or one-point perspective. Here we are looking right at the side of the model's head.

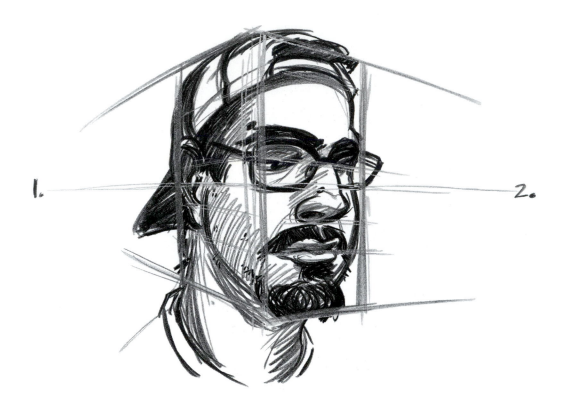

Mike Roth's drawing of Keith is in two-point perspective. We have the front and side of his head visible to us. The edge of those two planes is at the peak of his right eyebrow. That edge defines the forehead and temple planes. The drawing itself is solid. Look at the bottom of the nose and his upper lip. We see three planes of perspective in these features, but the head itself is not in three points. Also notice the slight pinching effect of the projection lines of the eyes nose and mouth. The glasses are obvious evidence of the two planes of perspective. Mike did an excellent job.

Here is a drawing of my wife Ellen. You can immediately tell that I was above her when it was produced. See the clear three planes of her head. Notice how her facial features block one another because of the perspective. An example would be her nose blocking her mouth.

Know how to draw the right angles of a box in space and then how to squeeze those angles to give your drawings even more depth. Pay attention to the vertical and horizontal lines and how they need to converge to suggest a plane progressing back into space.

You must be able to draw a cube from any perspective out of your head. This is a definite requirement of drawing well.

In my classes, for homework, students draw five heads a week. The way I have them do this is to first find a victim. (Don't draw from a magazine; it is flat, which actually makes the job harder.) Then they are to see their relationship to that person to figure out the cube of perspective the head is in and draw it. Lastly, the head should be drawn with surface lines to show structure. Later in the year, they move on to hands and feet with the same disciplines in mind.

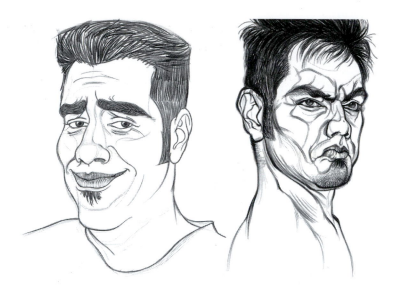

As a homework assignment, students create many drawings of their heads. Above is an example of Mike D.'s assignment in his first term and then in his third.

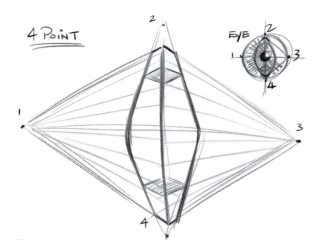

Four-point perspective

So here it is, four-point perspective in all its glory. It reminds me of looking out a window in New York City. If you were at the height of about the thirteenth floor and the buildings around you were thirty floors, this is what you would see. We have squeezed depth on both the vertical and horizontal planes with each having two points of convergence. This is the world of perspective we live in. The closer something gets to your eye, the more of a fisheye lens effect you will see. The centre of the object will emerge closer to you while its perimeters will squeeze away back into space.

The problem is, we are not normally close enough to objects to be aware of heightened perspective and not around the middle of objects that are large enough to look up and down.

What you see in the side-view mirror of a car is what you want to be aware of all around you every day. In production art, you will sometimes see this in camera tilts for storyboards or a layout.

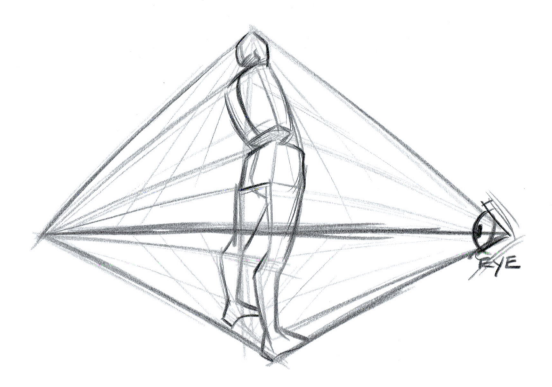

Here is an example of how four-point perspective affects the model. The first thing I try to make students aware of in learning to apply perspective to their drawings is having an awareness of their eye level and location in reference to the model. In the drawing I have done, the eye level or horizon line is at mid-thigh.

I have chosen these next four figure drawings for you to see the reaction of four-point perspective. Make yourself aware of where the artist's eye level was. The way to do this is to see where the body seems to go flat for a moment, a place that you cannot see above or beneath, where you are looking head on at the model. See where the closest edge of the box of space that the model occupies is in reference to you. In most standing poses, my eye level hits right around the mid-thigh of a model.

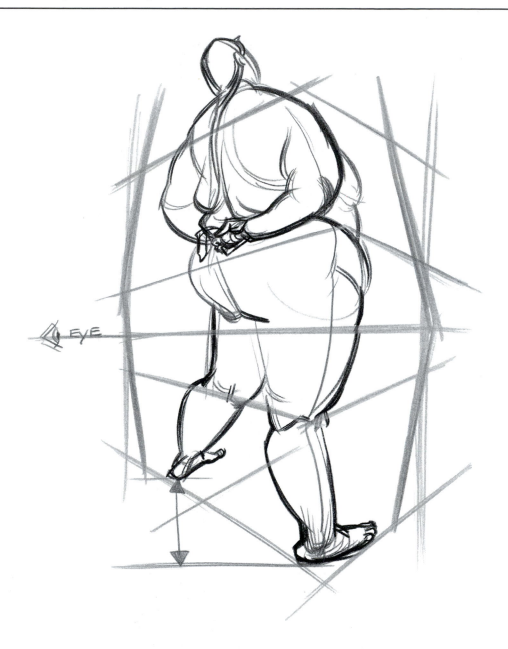

This drawing is terrific for seeing the perspective set up between the model's two feet. Because they are connected with a line, we are given a direction towards the left vanishing point. As a visual reminder, when drawing a model's feet, notice the height difference of the two on the page (as I have drawn with the arrow). From there, you can see how the rest of the body is affected by the guidelines of perspective I have drawn. The closest edge of the box of space she occupies is represented by the contour line running down the right side of her body.

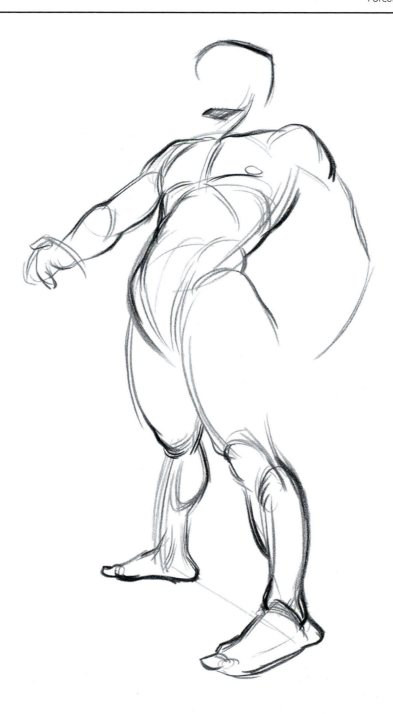

See the angles of his feet, knees, hips, and jaw. Here it is the hips that are at my eye level. Look at the line running over his left shin that defines its form and direction of force.

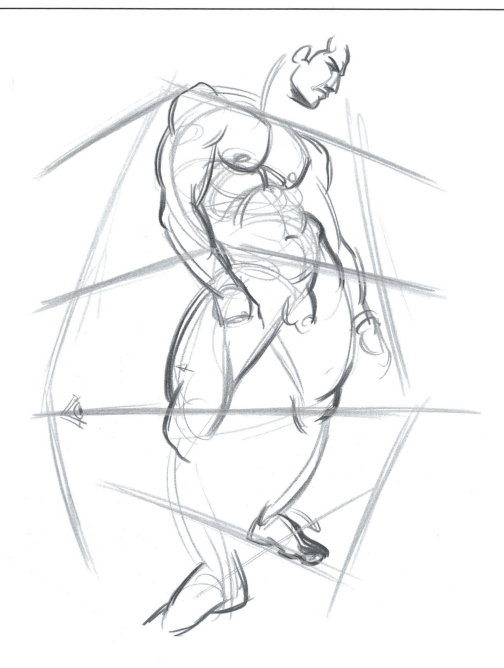

Here the feet and shoulders happen to fall on the lines of perspective the body is in. See how the hips do not do the same. The model's knees are at my eye level or horizon line. The body is complex and can move to present various different perspectives in one pose. You must be aware of your eye line and how the entire pose sits in four dimensions.

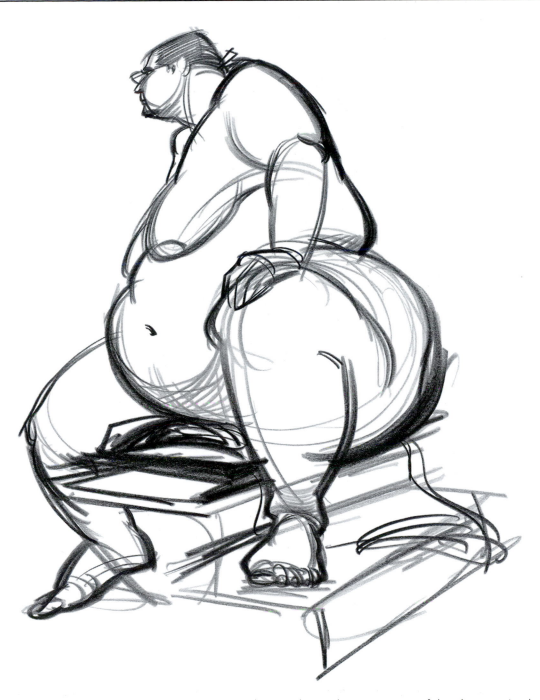

The steps the model is sitting on are our most obvious clue to the perspective of this drawing. Look at their angle relative to that of her breasts and shoulders, or the straight line that represents the back of her head. There is a strong sensation of looking upward at her here.

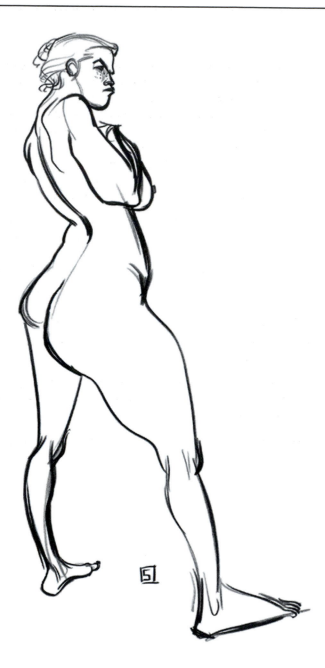

This drawing gives us a sense of depth through height and from left to right. Here you can clearly see the perspective angle between the feet. In fact on her right foot, I put the angle of perspective down the back of the heel and the right side of the foot. Her shoulders also angle down away from us.

STRUCTURE

Anatomy is structure in drawing the human figure. There are too many books out there about anatomy for me to take up a chapter on this. If you feel uncertain in this area, it helps for you to have a book that shows basic understanding of the placement, relations, connectivity, and workings of the major muscles of the human body. Some books I can recommend are Bridgeman's "Complete Guide to Drawing From Life," which is stylized, but the drawings are forceful and he explains how things work. Another book is "Anatomy for Artists" by Jeno' Barcshy. It is informative and the drawings show some of the mechanics of the body. Lastly, Elliot Goldfingers's "Human Anatomy for Artists." This book considers the body's muscle groups and draws the layers that create a given area's anatomy, from the skeleton to a photograph of a model's actual musculature, as we would see it.

Drawing through the figure is probably the fastest way to start your journey on forceful form. You will see this in most of the drawings in this entire book. This shows the difference from someone copying the model to someone attempting to understand what they see. Don't let an arm, leg, or any other part of the body block you from comprehending what is happening in front of you.

Surface lines

Many art classes teach students to draw the figure with cubes and cylinders. I believe that this is a good foundation for artists. It allows you to see the angles and planes of perspective on the body as we just learned them.

The human body happens to be a little more complicated than just boxes and cylinders, though. In this part of Chapter 2, I will show you drawings that possess lines that evoke force and describe form. This will occur with the use of surface lines.

Going long in Chapter 1 was the beginning of seeing force wrap around form. Now we will focus on the forms.

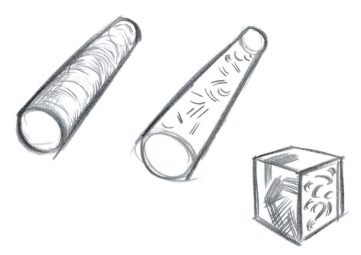

Here we see surface lines with simple structures. The cylinder on the left shows lines that adhere to and go around the form. Some of them pull along its surface from end to end. On the right, we see lines that do not explain the surface of the cylinder. They seem to carve into it instead. The box on the bottom shows us how to describe a flat surface with line. You can also describe a change in planes with surface lines. As with the cylinders, inappropriate lines cut into the surface of the right side of the box.

Many drawing classes have an exercise called "blind contour" drawing. In my classes I have students perform "blind force" drawing. The difference between the two is huge. Blind contour is done to teach you to copy the "edge" of the model. Blind force is an exercise that persuades you to see force travel through and around the model. It is extremely exciting.

Forceful flight

So, let's start the process of blind force. As you are sitting and observing the model, I want you to use your imagination to "fly" from your seat, like a tiny, ant-sized airplane and make your way across the ocean to the land of the model. The model is hundreds of miles high and wide and has miles of depth. You fly across the model's landscape to that first sweep of force. You start drawing along with the movement of your forceful flight. You fly over mountains, across plains and hills. Your eyes, mind, and hand are all in the same place at the same time. You *must* concentrate on being present! Did I mention that you are not looking at the paper? This is similar to the roller coaster with the main difference being blindness.

There are other skills we learn through the blind flight. One of the most important is you getting in front of you paper, not behind it. Students' egos are what get in between them and the model. You must move out of your own way to truly see. I remember trying out this exercise myself and after a few poses, the massive weight of responsibility for the appearance of my drawing slid off my shoulders. As I mentioned at the beginning of the book, don't make the act of drawing about your drawing, make it about your experience while drawing. The drawing itself is but a by-product of your time with the model.

The leap that students take in this process is inspiring! You become aware of how much you lie when you draw and how much more interesting reality is than what your mind can come up with. Boring drawings occur because you have not created a vast enough library of reference from years of drawing from life.

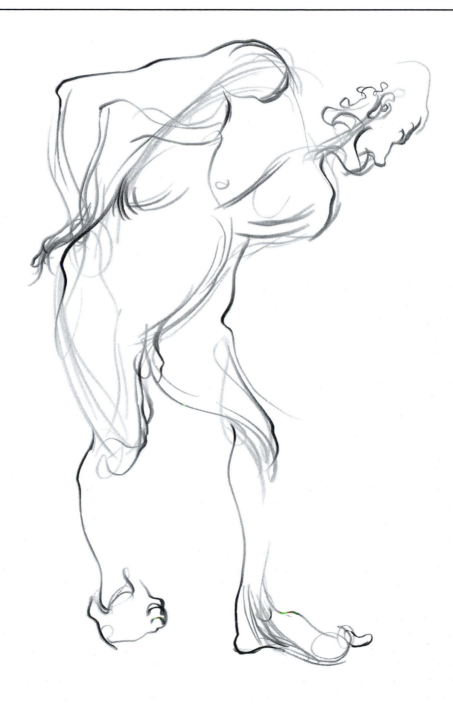

Here is a two-minute blind flight drawing. I remember looking at the paper once. I completed the entire pose except for the model's left leg. Look at the information of the right knee and left foot. These locations show the beginning of forceful surface lines.

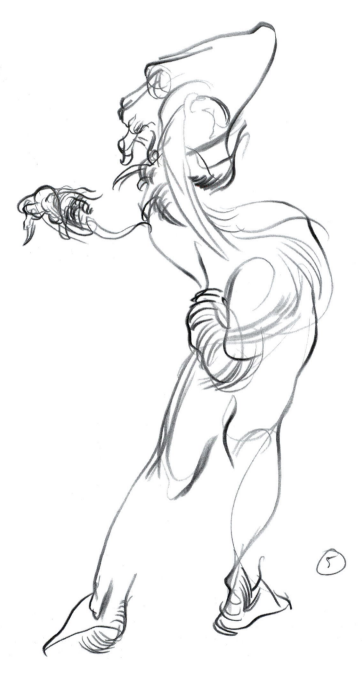

This five-minute blind shows an exciting experience. Look at the rhythm of the ribcage to hips. Notice all of the form in the left arm, scapulas, butt and feet. Look at the line variety again. I love the feel of force trying to escape out of the right hip and abdomen and then reconnecting back into the right buttock.

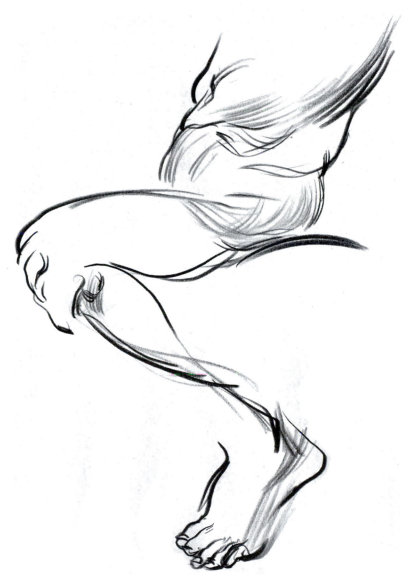

The entry of this blind flight ride started at the top of the drawing, along the ribcage where I quickly slid down the path of FORCE, across the abdomen and over to the hip. Notice all of the sculptural surface lines in these regions of the body that express my interest in their FORCES and forms. Travel down the leg presents the speed of transit to the boney ankle and heel in the foot.

With more time, look at what can be accomplished. Mike D. had a rich experience here. This exercise teaches students to draw "inside "the figure instead of the contour. In truth, there is no contour. The edge of the model is coincidence relative to where you sit. This flight makes you aware of the model's structure or form.

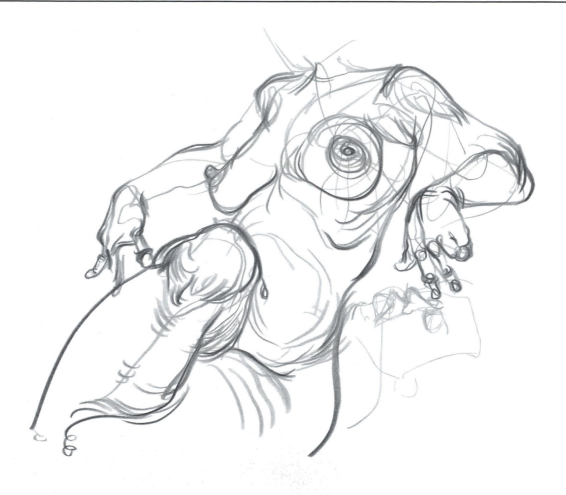

Throughout the process of blind forceful flight, I give students more opportunities to look at the page. For instance, at the beginning they look down every minute, then thirty seconds, fifteen and finally when they decide to. Here is a drawing of Mike D.'s that is under his control. Look at the level of specifics with fluidity and form. It feels close to the model. See the interior line work that sculpts the models forms. This leads me to our next topic of forceful form.

Sculpting force

Forceful form will help you get away from the edge of the body, or its perimeter. The model takes up space and you want to be able to explain how. You will learn to see force throughout the entire form and this in turn will make you aware of structural and rhythmic connections. Remember that the edge of the model exists because of where you are seated relative to the model. If you or the model were to change location or position, the edge would change.

Pay attention to the location of the natural centre on the forms you understand. For instance the nose on the face, the centre of the ribcage, or the belly button on the stomach. You obviously have the

spine for the back. On the legs you find the model's knees and the top of the foot. For the arms you can use the center of the biceps or deltoid to explain each of those different planes.

Going back to hierarchy, think about addressing larger structures first and then smaller ones. Understand the direction and form of the ribcage before you draw the muscles attached to it. I remember when I was first experiencing the enjoyment of seeing space, it was because of an instructor telling me to imagine I was an ant crawling over the surface of the model's body. Everything is large in comparison to you. It is a new landscape for you to explore. Hills, valleys, and plateaus will appear on your trip. Ride the rapids of force in the figure. The more you can believe what I tell you, open up your mind, and envelope what you see, the faster you will obtain awareness of space.

Another exercise in drawing form is for you to act as if you are sculpting the model with your pencil. Draw as though you are caressing him/her with the pencil's tip. Feel the forms in your mind and express them on the page.

Sometimes students confuse this exercise with drawing shadows. We are not looking for shadow; we are looking for form through force.

Michelangelo comes to mind when I think about line showing force and form. He was the master at making a complex group of muscles, such as the back, work together as a whole. This is no easy task. The vast sea of bulges and depressions could leave any artist confused and lost.

In the beginning of the twentieth century lived a man named Charles Dana Gibson. He was best known for "The Gibson Girl." His lines dealt mainly with structure. Everything occupied space as he illustrated scenes from that time period. Dover publishes an excellent book called "The Gibson Girl and Her America: The Best Drawings by Charles Dana Gibson." I fortunately almost tripped over two large, old volumes of his work on the floor of an antique shop in South Jersey. Definitely a precious find.

Heinrich Kley was an artist I had never heard of until representatives from Disney told me about him. At that time, I was lacking form and Kley's drawings were not. Kley was a German artist who did satirical cartoons for Germany's newspapers. These illustrations are full of life and creativity. He draws everything with solidity in mind and uses line to do it. He draws centaurs and satyrs, dancing elephants and gators, giants and fairies, all in service of his political opinion. His book is readily available and it costs fewer than ten dollars. "The Drawings of Heinrich Kley" from Dover. This is a worthy investment.

A contemporary master at giving line force and form is Frank Frazetta. Some of you may know him as the great fantasy painter that he is, but his black and white ink work is intelligent and beautiful as well. His brush strokes evoke solidity and force at the same time. Check out "Frank Frazetta, The Living Legend," to see some great examples of this.

Go and see the sculptures of Richard MacDonald to get a sense of what your drawings should evoke. His sculptures are incredible representations of figures that occupy space through rhythm, form, and poetic power. His work can be seen on his website of the same name.

(Again, don't copy the model; instead, recreate him or her.) You must rebuild them on the paper. I usually give the students ten-minute poses to actuate these exercises. Also start to consistently draw the hands and feet within each drawing. They add another level of expression to the images you create.

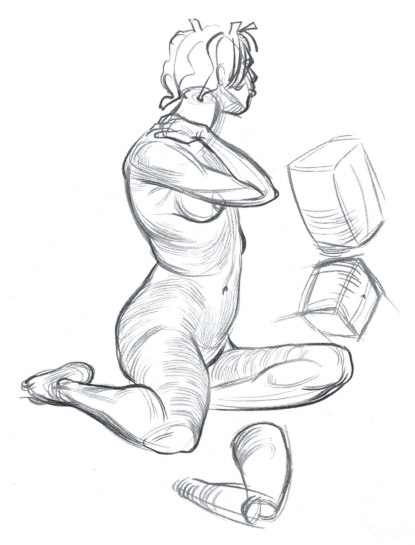

So, here we are, the model in perspective and showing form through sculptural lines. See how most of the surface lines sculpt the model's space and also move in the direction of the force of that part of the body. As an example, see the surface lines along the ribcage that give us its form, but also the sweeping upward sensation caused by the model's raised arm. Also look at how the surface lines of the ribcage and hips help to explain their different directions in space, which aids in telling a clearer story about the pose's ideas.

I've drawn this as simpler masses on the right. The right leg in relationship to the hip is more severe in perspective. It comes out towards us more rapidly than the hip. The calf also rapidly descends back into the page. The capacity to create three-dimensionality or a sense of deep paper is a miracle of drawing.

I have students cover as much of the model's body in forceful line as possible to speed their process of understanding. The more you do it, the faster you will learn it.

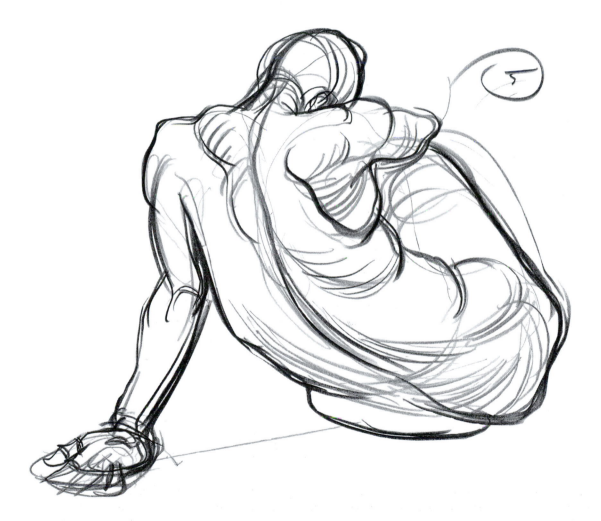

Look at how the lines evoke a direction of force and form at the same time. See how the lower back sweeps into the legs. His left arm opposes this major direction by going in the flip direction.

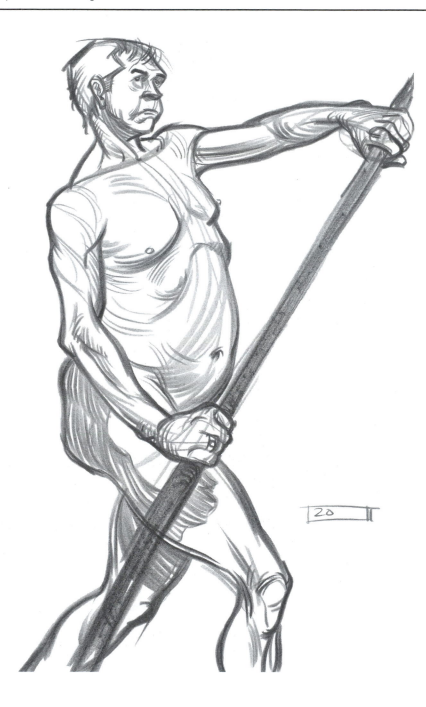

So here we have an experience in sculpting the model. Look at the surface lines of the left forearm. They show us the volume and how force sweeps down towards the hand. See the shadow on the leg, and how I adhered it to the body instead of creating a flat shape.

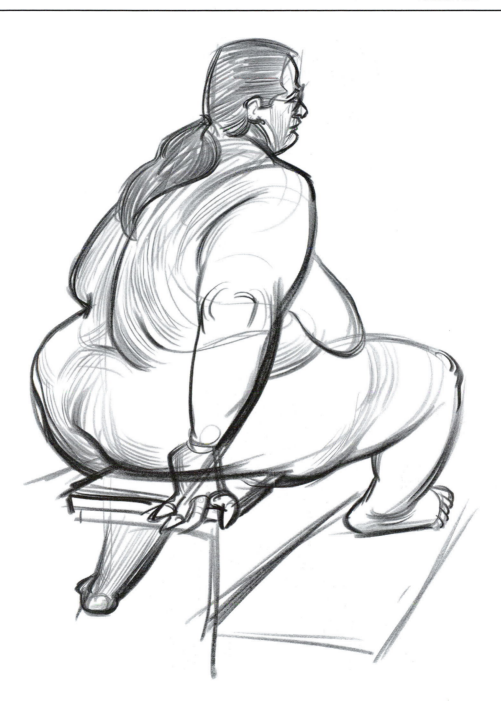

Look around this drawing and see how the lines of structure also describe force. I started this drawing with the sweep of the back. Notice the straight, hard moments of the shoulder, hand, and head.

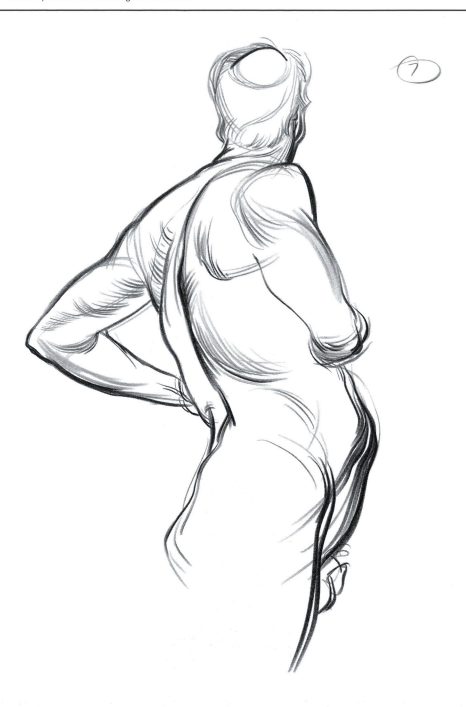

Again, surface line helps describe forceful form. We see the direction of forces and how the forms are affected by them. Look at the ribcage sweeping to the belly. You can see rhythm in the deltoid and the outer edge of the tricep.

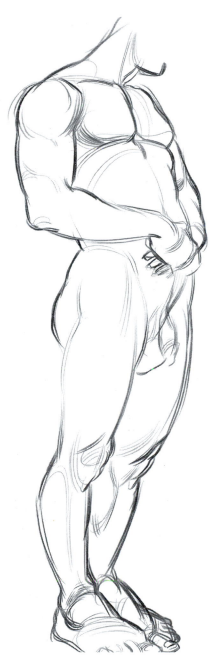

Here there is less physical drawing. The lines are used in an efficient manner to help us feel the solidity of the model's forms. The thickness of the feet and pressure put upon them by the model's weight are revealed by all of the surface lines here. Look at the knees and the roundness of the ribcage for more structure. This is still in four-point perspective.

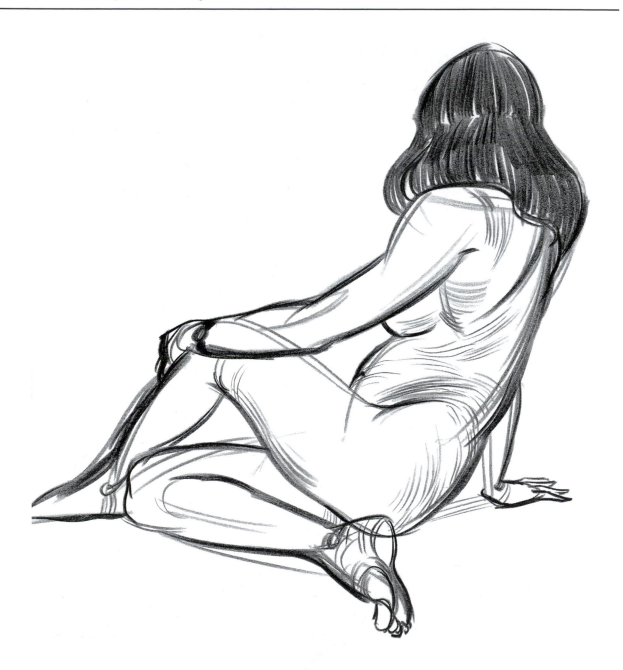

Here you can see how the place where the ribcage and hips meet is furthest from us in perspective for those structures. See how I handled the hair to show solidity.

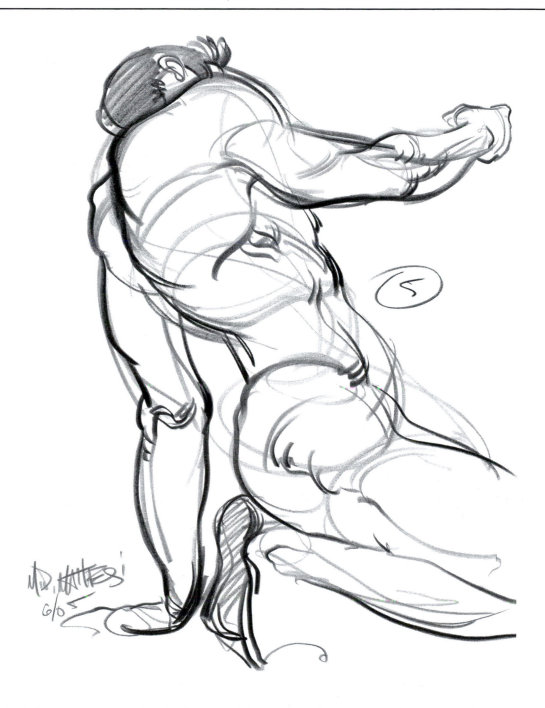

Here is high drama and speed with efficiency of form. Notice the repetition of grouping of two or three marks in strategic areas showing the direction in space of form. For example the oblique, the top of the leg and the forearms.

SPATIAL CONCEPTS

Overlap and tangents

Let's address some visual rules of space.

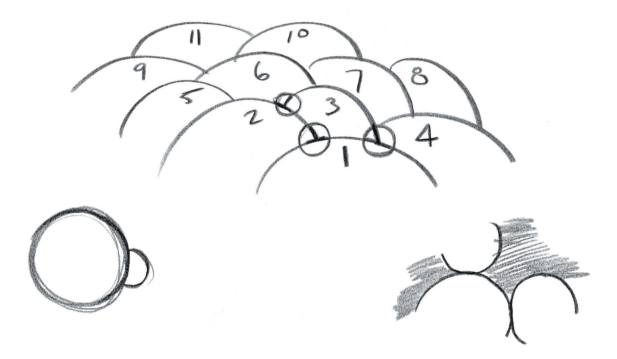

The first visual rule is overlap. See how it is that shape 1 is closest to us and 11 is furthest away. This is all done with overlap. Overlap occurs when one line stops as it touches another. This makes it appear as though it has gone behind it. The circles in the bottom left corner also give us this depth effect. I have heard some instructors call this the "T" rule because of the intersection creating a "T."

At Disney they made a huge fuss about tangents, and rightly so. As the drawing at the bottom right shows you, if you have a tangent or two lines meeting, neither takes dominance in space and we have flatness. Decide what is closest to you and see the journey back into space. All three of the circles feel as though they are on the same plane. Overlap helps evoke foreshortening.

With all of these concepts in mind, as you draw the model, ask yourself what is closest to you and what is furthest away. Enjoy the journey between the two moments.

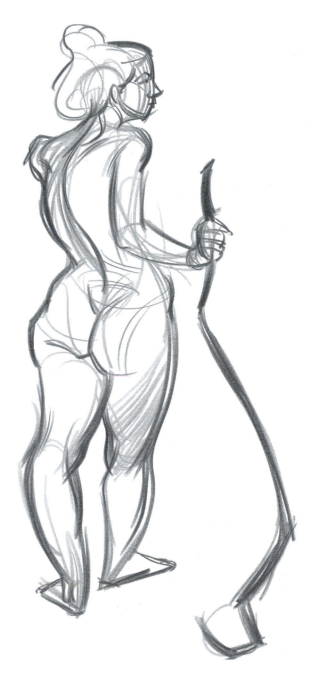

We have come to the point where we have a solid structural drawing without all of the surface line. The centreline of her back, her spine, helps set up all of the structures. The buttock and hip area shows plenty of overlaps describing depth. Look at where two lines meet and which one moves over the other. The form it describes is in front.

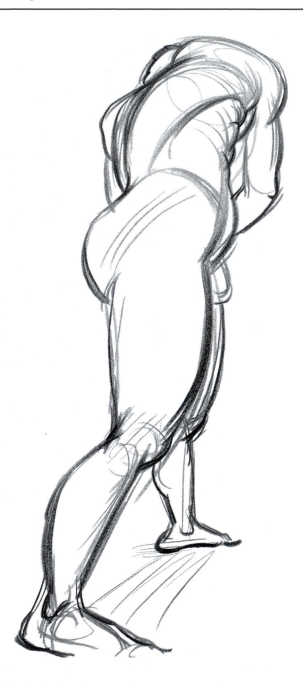

Here force makes an aggressive vertical climb up the model's right leg. When we crest the hip we quickly shoot back into space over the upper body. See the hip in front of the stomach, with the ribcage beyond it. Look at the lats, and the shoulder blade resting on the ribcage, and the head over the horizon. Overlap helps divide the back into left and right halves.

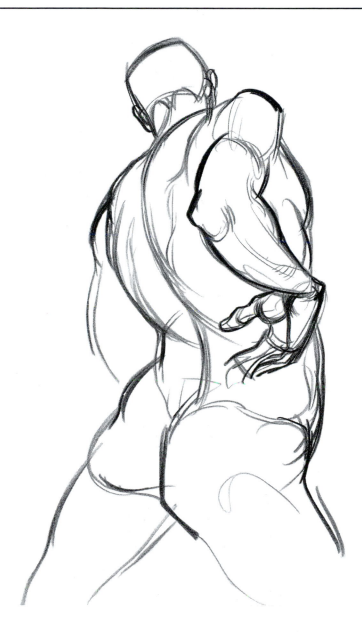

In this drawing, the model's elbow is closest to us. The rest of the model falls behind it. See the straight places that show us the angle of the head, the hardness of the shoulder and hand, and the strength of the lower back. A quick visual aside: I was taught that a heavier edge on an object with less interior information makes an object punch forward. Now when I draw this comes to me automatically. I see closer objects as having thicker edges to them. In this drawing, it helps push the entire right arm slightly away from the model's body. In the end, you are trying to show your thoughts as clearly as possible, so this is another approach to consider.

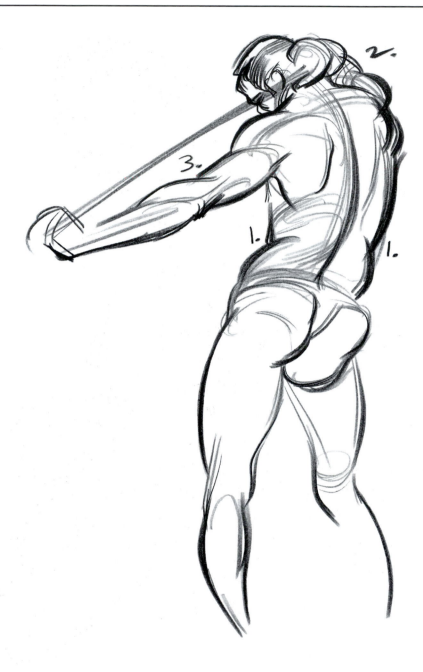

The most telling overlap here is the ribcage stretch beyond the hips in depth at 1. His right arm has extreme foreshortening at 2. We move from the deltoid to the bicep and elbow into the page. Then we make our way out from the forearm to the hand with the face lying just beyond it. The left arm at 3. has a more casual progression through space still created by overlap. Also see the sweeping surface lines that assisted me in finding the model's forms.

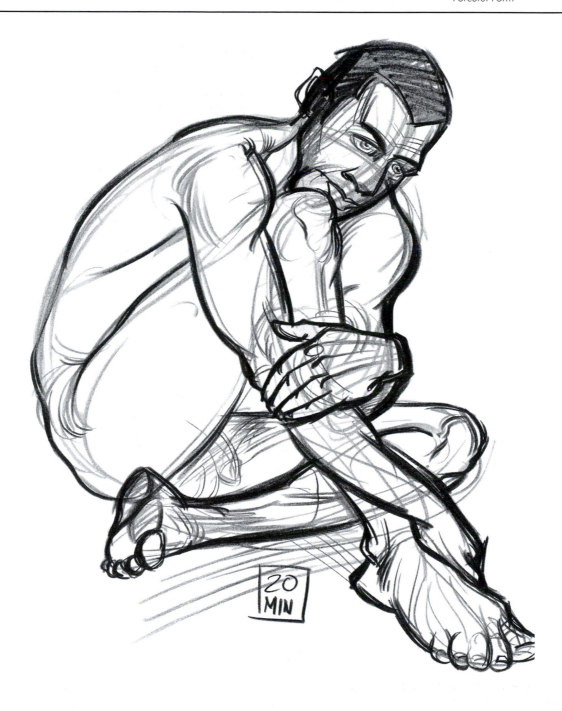

The success of the overlaps is what makes this drawing legible. Besides all of the overlapping moments, notice the surface lines on the deltoid that sweep us down into the rhythm of the arm.

Size and foreshortening

Size matters. The larger an object is, the closer it will appear. Therefore, the smaller an object the further away. This rule will help explode the boundaries of the paper, thus fooling the eye into seeing depth. We are so conditioned to this rule in our everyday lives that something as simple as the size of a circle fools us into seeing space. The more you force space into your drawings, the more conditioned you will become to seeing it in everyday life. To provoke the sight of space, try drawing the model from a closer position than you usually do and exaggerate size. Make things ridiculously small or large. This will help you see the power of size.

Imagine what would happen if while driving, all of the cars on the freeway around you were the same size, no matter how close or far from you they were. Size tells our brain about the drama of depth.

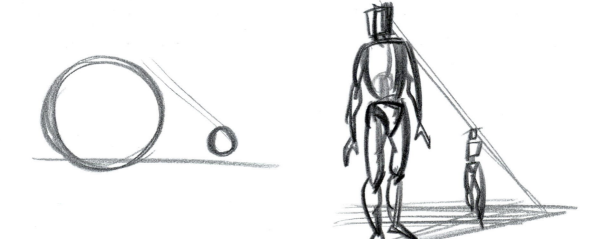

Look at how effective both examples of this are. We are forced into believing we see depth when it is only the size of the object that has changed.

Try drawing as close to the model as possible. This shorter distance will help you experience more depth. The further the model is from you, the flatter they will seem. This should begin to help you see direction into and out of the page.

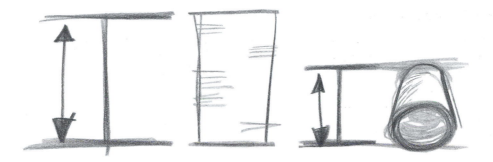

Foreshortening is shortening the lines in the drawing to create depth. In this drawing we have a tube. Its distance from top to bottom is shortened in the drawing on the right. This immediately tells our brain that it is coming forward. The combination of foreshortening along with size develops dramatic depth. When students ask me about foreshortening, the first suggestion I have for them is draw what you actually see. Your mind wants to flatten out what you see. Accept the truth. When a leg for instance is foreshortened, look at the distance between the joints. Notice how close they are to each other.

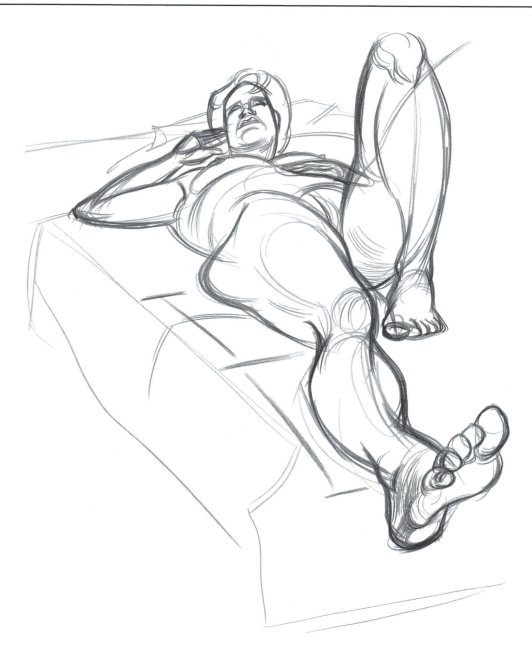

Since space, or depth of the page, through size is our focus, look at the size of the model's right foot relative to her hands, head, or most importantly, her other foot. This is so important because if two of the same objects are different sizes, we immediately make a visual connection that helps us realize a change in perspective or distance between them. You can also see some moments of surface line here. Down the model's right leg I drew the distances between her joints. Imagine her standing and how much longer they would become.

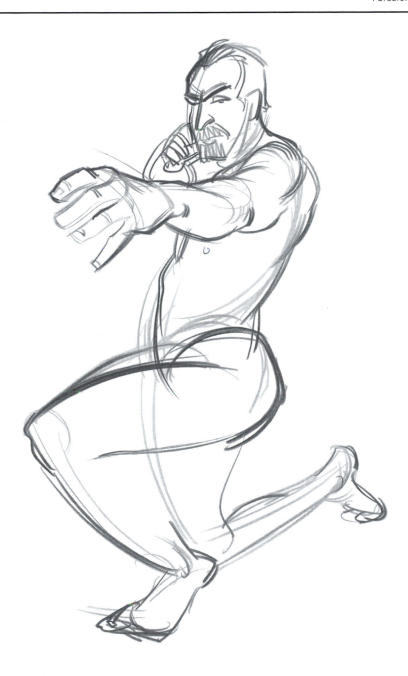

In this drawing, his left hand is the object that is closest to my eye. The reference of his other hand helps the spatial illusion. See how I structured his arm and hand in the depth it occupies. Now overlap helps describe form in a foreshortened space along with the shortened distances between the joints of the arm.

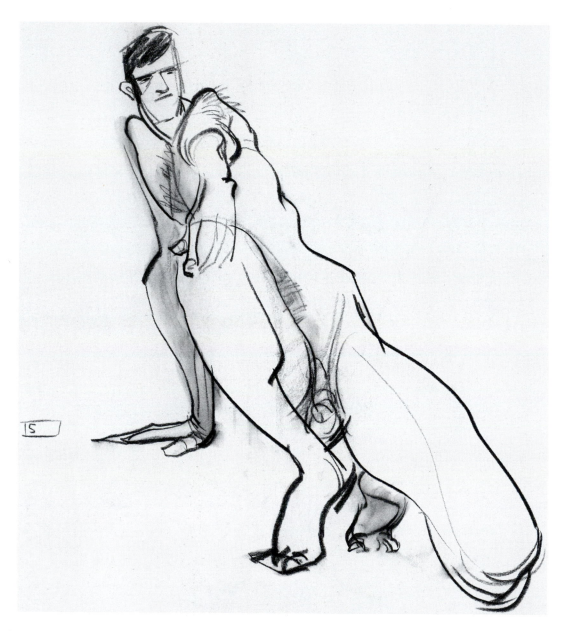

Abstractly speaking, the first idea that defines this drawing's dynamic appearance is the powerful forty-five degree angel the pose rests on. Along this angle resides much depth from the close knee to the model's face and the down to the hand that endures the majority of the model's weight. Tight foreshadowing and overlap on the raised arm presents intense FORCES in a compact area on the page.

I love the upward climb. Starting at the left foot, we have an invigorating journey ahead before we reach the model's face.

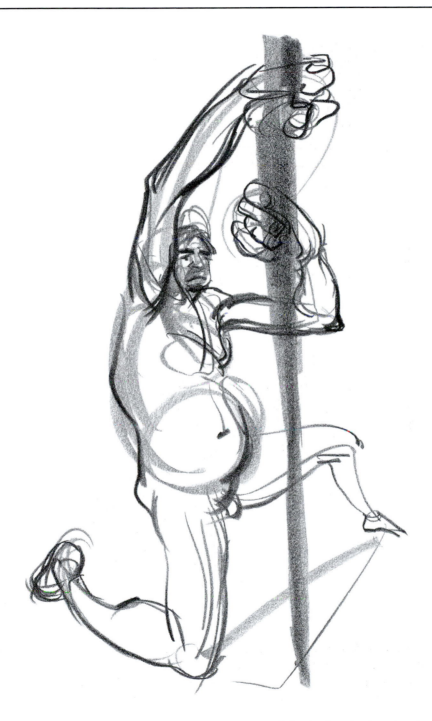

Here is a fast and aggressive drawing showing a vast amount of depth. See the hands relative to the model's face. Look at the distance in the feet. The back foot is tiny in comparison to the hands.

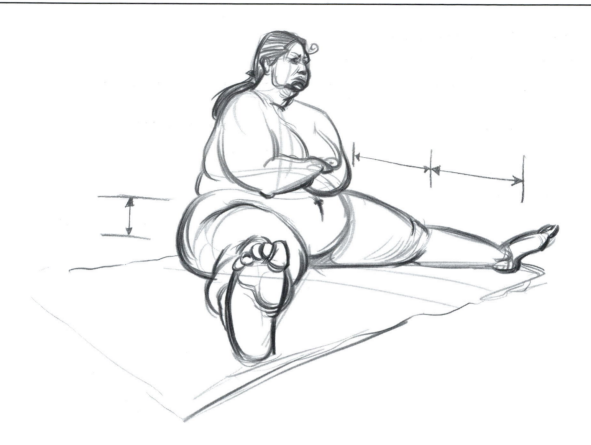

Our triangular trip through space takes us from the model's right foot to her head and then to her other foot, where we see a digression in size that makes us see space or depth. Again, also notice the overlapping to force space. See the foreshortening of the model's right leg relative to the left. Look at how close her big toe is to her hip!

All of the topics covered in this chapter are to assist you in describing forceful structure. You need to be capable of describing forms moving with rhythm in a four-dimensional space. In animation, surface lines are not evident in the finished product. Moving shapes are important. These shapes are created via a true understanding of force and form, or in simpler terms, curve to straight. That is the topic of Chapter 3, forceful shape.

FORCEFUL FORM EXERCISES

1. Learn four-point perspective. See the model in space.

2. Practice blind force. Travel with your mind's eye beyond your paper to the model and follow the path of force around the surfaces of the model.

3. Sculpt the model. Think about actually touching them with the tip of the china marker.

4. Draw your head many times to see two- and three-point perspective.

5. Pay attention to anatomical centers.

6. Learn anatomy.

7. Walk around the model to become aware of roundness. Sit close to the model to see depth.

8. Get in front of your page while drawing, not behind it.

9. Pay attention to size and overlap.

Chapter 3
Forceful Shape

John Ruggieri and the late Jack Potter, both of whom were instructors at the School of Visual Arts, helped me to recognize shapes in life. This made me curious about their expressiveness and efficiency. It is exciting to see the world in shapes. Everything has shape.

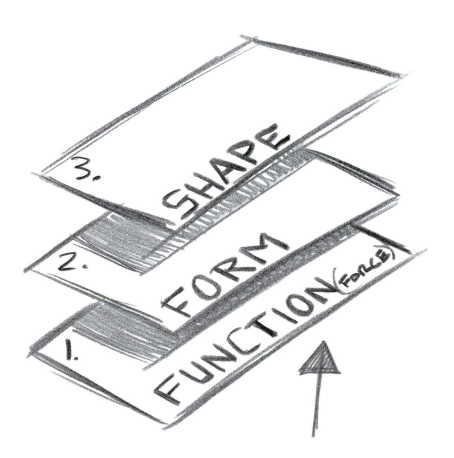

Let's make believe that we are looking through filters when drawing. In Chapter 1, the filter we peered through was force and its different aspects. The previous chapter's filter was form and some pictorial tricks that gave us space. This chapter's filter is shape. Shape exists because of the first two filters.

Shape gives us immediate width. Shapes can wrap around form to describe a particular mass. In animation, shapes change from drawing to drawing, which also helps present form.

SILHOUETTE

Again, let's enjoy shape in a hierarchical manner. The biggest, most encompassing shape is the silhouette. The silhouette is the filled-in shape created by the outline of the entire object. It is a vital element to animated drawing. A silhouette helps us see the whole body clearly, without any interruption. You can see if the story of a pose is clear in its silhouette.

It allows you to see how all parts relate to each other on a flat plane. Here it is the size of shapes that gives us depth. As I will show you, shape can give you force. A good silhouette can even imply form by its overlapping shapes. Silhouettes can tell you about character, emotion, and much more. There are two different kinds of shape: forceful and un-forceful, lively or lifeless.

"What is conceived well is expressed clearly."
Nicholas Boileau

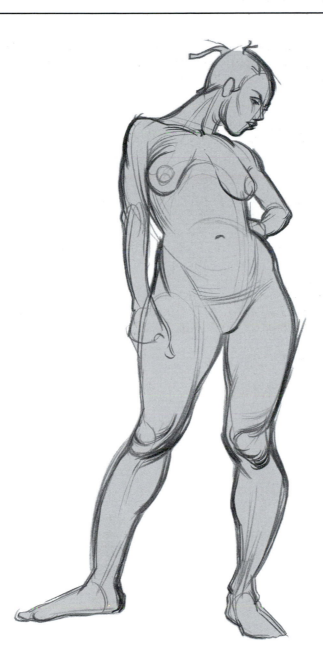

So here is a silhouette of a full female figure. Notice the positive and negative space. There is so much said with just the silhouette of the figure. We can still see how force pushes this flat shape from left to right down the page. Don't forget that the silhouette comes from form. That is why it is the third chapter! You must clear to see these flat shapes from structure.

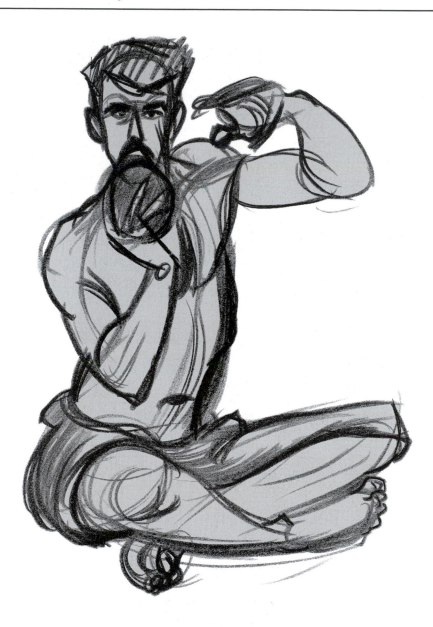

Keith's drawing has a great deal of force and form. You can tell he saw the connection between the upper and lower body. I love the "drawing through" in the left arm and also the head seen through the hair. The forceful shape he saw in the model's left hand is excellent. The drawing's major problem lies in its silhouette. The orb the model is holding gets lost within the shape of the body. The left arm is a clear read. I don't have students make things up to suit their needs, but what Keith could have done was physically move to obtain a better vantage-point of the pose for a clearer silhouette.

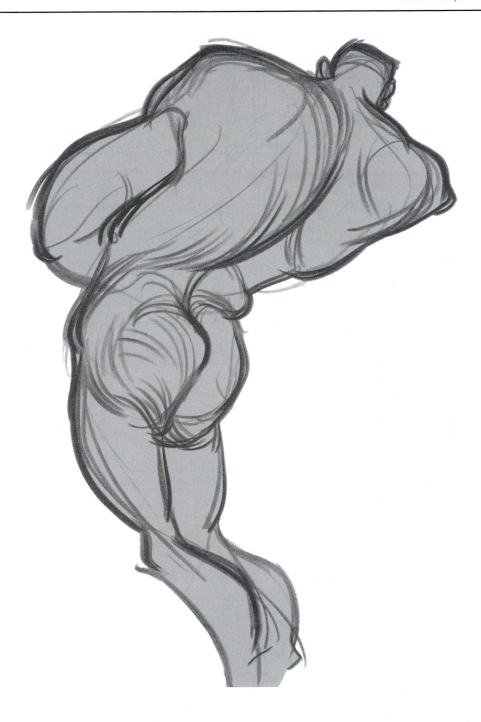

This drawing by Mike D. has a very clear silhouette that was designed from force and form. See the rhythms and how applied force pushes into the right shoulder and then shoots into the left.

The top of the page shows us three shapes: a circle, a square, and a triangle. None of these shapes evoke force or form. They have no forceful direction because of their equalization and symmetry in shape. They are without force. The shapes underneath are full of life and fluidity. I filled the bottom shape with contour lines to show you how the shape still is filled with structure.

A forceful silhouette is a great opportunity to show us all of the above because the silhouette changes shapes, overlaps, and size. Shape is great for seeing angles and thickness, and gaining a new awareness that you can have an opinion about.

FORCEFUL SHAPE

Here we have the silhouette of a porcupine and a water balloon. One shows us hard, pointy aggressiveness while the other is soft and placid. Nature has already done a tremendous job of designing its world. To break both of these shapes down to their simplest components, they are both created by the relationship between a straight and a curved line. The curve represents an upward force while the straight tells of the hard surface on the bottom of both forms. This straight to curve is the beginning of forceful shape. Look for this shape in the figure drawings that follow.

Working at Disney made me realize that there is such a thing as appealing and unappealing shapes. I prefer forceful and un-forceful shapes. If you truly understand something's function, it will be appealing.

To discuss un-forceful shapes, look at the old cartoons where the characters had rubber-hose arms and legs. The shapes of their appendages did not lend themselves to asymmetrical, forceful energy. Their parallel quality created dysfunctional shapes.

Disney's first feature films suffered from softness. Everything from characters to backgrounds was primarily created from curves. The animation was excellent, but the designs were weak. Believe me, this is no critique of the stories either.

It was not until "Sleeping Beauty" came along that the studio really caught on to straight to curve design. Although the film was a financial failure, it changed the design principles of the studio. The dramatic modification took the studio to a contemporary style and thought process that has evolved to the efficient and graphically strong appearance that it has today. Because of this "Sleeping Beauty" was a great success. It changed the face of American traditional animation.

In "Disney Animation, The Illusion of Life" by Frank Thomas and Ollie Johnston on page 68, there is a small box that discusses appeal in drawing. It has so much importance yet it is easily passed over in the book. It briefly talks about the theory that the studio stands on!

I freelanced for Walt Disney Consumer Products before going into feature film and the guys there were great at appeal. New York's artists were mainly drawing the traditional Disney characters. That is where I learned what a great example of appealing design Mickey Mouse is. I heard that tests were done wherein babies were shown an image of Mickey, and they would smile and laugh. *That* is appealing design!

The artists kept telling me to design more. I did my damnedest to make the characters look right and I thought I was doing a good job. I look back at those drawings today and just want to thank them for giving me any work at all. They were dreadful. They lacked the spark and clarity of design they should have had. It took me four months down at the studio in Florida and some great "Timon" drawings in front of me to finally understand appealing design. It's strange how the light bulb just came on. Once you fully understand the theory, you realize just how applicable to reality it is.

Look at the Batman cartoon of today. Bruce Timm has done a great job of designing a character from a different medium, in this case comics, and converting Batman into an appealing cartoon design. This design principle has made it possible for the animation to be of higher quality than it usually is. Intelligent simplicity has lead to a greater product. Samurai Jack is also fantastic because of the amount of forceful shape applied to the design theory of the cartoon. Characters and backgrounds are affected. Here you can enjoy it in a graphic, raw representation created by Genndy Tartakovsky.

Appealing design, or what I like to call forceful shape, helps us see force and form in the construct of a shape. We do this by being aware of straight to curve. We touched upon this in Chapter 1 as it related to force. Now the relationship of the different forceful lines creates forceful shapes. Straight is hard structure and curved is flexible force.

The trap in trying to draw with shape in mind that I find students fall into is forgetting about force and form. The theory of forceful shape is not something you have to assert upon the figure. Like the previous topics we've discussed, forceful shape is a reality. Learn to see it.

Effective shape comes from force and form.

The Do's and Dont's of Forceful shape

Since we have gone over what kinds of lines create force and form, let's discuss what kinds of shapes do and don't. Notice their similarity to the rules of force from Chapter 1.

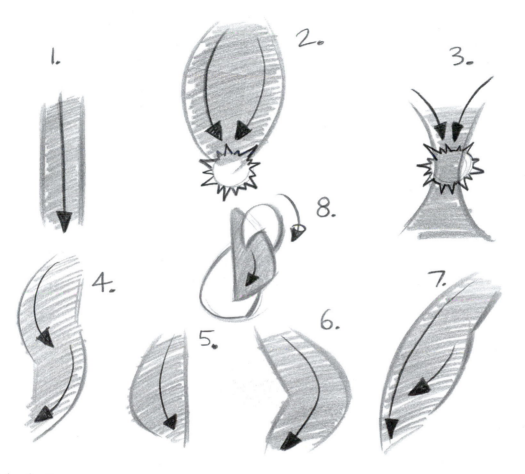

First the don't:

1. Don't create a shape with parallel lines. Force has no way of moving obliquely through the body. As we will discuss further, human anatomy is not built in a parallel manner.

2. Don't have the same kind of force on either side of the same shape. I call this mirroring. Here the forces crash after doing their function.

3. This is similar to number 2 in that the forces mirror each other. Here they collide at the peak of their function.

Now let's talk about the do's:

4. Do draw oblique forces. This is what creates rhythm. Think of the skiing analogy I made earlier.

5. Do see straight to curve simplicity in the figure. Here we have created a shape that has function or force to it. It is appealing because of its contrast in ideas, and it also has direction. There are no mirroring moments.

The curve is the energy that moves through the shape, and the straight helps direct its path and give it structure.

6. Do see different kinds of shapes. Here we have straight to curve again, but represented in a different shape.

7. Do see the massive variety in which these rules can be applied. Here is a curve against a straight and a curve to give us a play of forces.

8. In this example, I want you to see how shape can explain form. Where the white shape overlaps the black shape, it describes its surface. The spatial concepts come in handy now. Size, overlap, and tangent theories help shape gain structure. You should still help yourself feel form to see more convincing, clear shapes.

An artist that I utilize to show students the graphic yet functional effect of straight to curve is Mike Mignola. He is the creator of "Hellboy," the comic book. His brilliant designs show forceful figures in a simple and efficient way. Check him out! His new book, "The Art of Hellboy," is awesome.

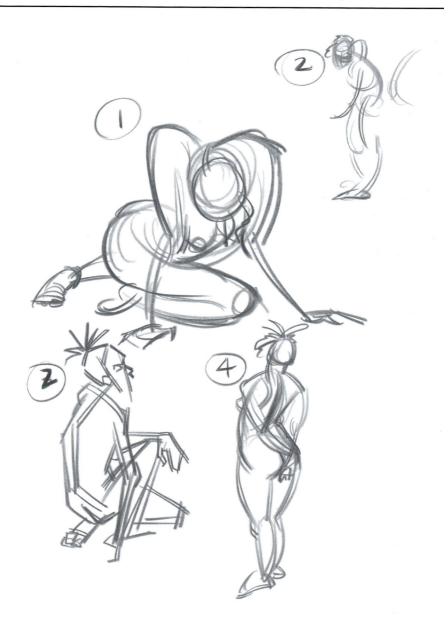

I want you to see the differences between the effects of straight lines versus curved ones:

1. Here is a forceful drawing with strong curves that move us through the model.

2. Look at what happens to energy when the figure is drawn with only straight lines. There is no forceful power. The drawing seems to be more about angles. If a figure is drawn out of only straight lines it has no energy, and if it is all curves it lacks strength and structure. The balance of the two within every shape gives us drawings with a sense of believability through contrasting forces.

Here is a sample of just how efficient you can become with your line through the power of forceful shape. Look at the level of abstraction found here. Overlap becomes essential to fooling us into seeing depth on the page.

Going back to the hierarchical way of thinking, shape can be used on a large scale, first to address the greater issues and then the smaller ones. Again, we will start in a generic, graphic manner to pursue the issue of straight to curve design and then move onto specifics. Big straights to curves first.

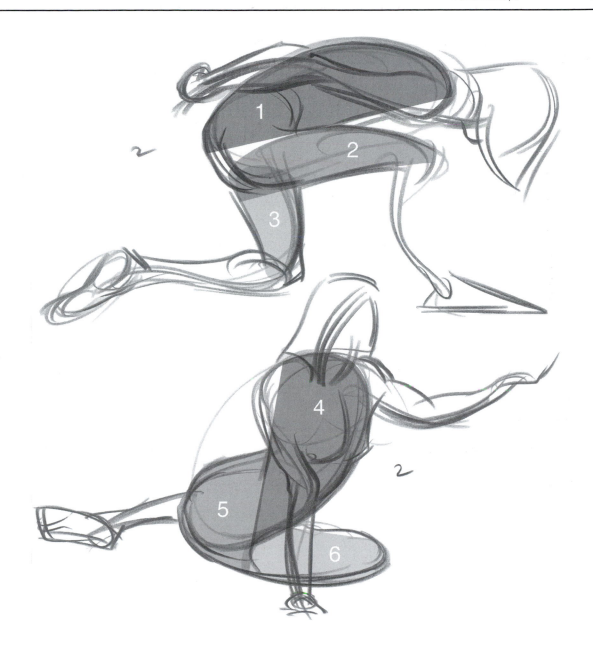

See the animated shapes in these drawings. Notice the absence of mirroring and how there is a straight for every curve of force. See the silhouette. Shape 1 and shape 4 both represent the torso of the body. In this comparison, they are opposite in function. Shapes 2 and 3 are basically the same idea for both legs. See how shape 5 seamlessly moves us into shape 6.

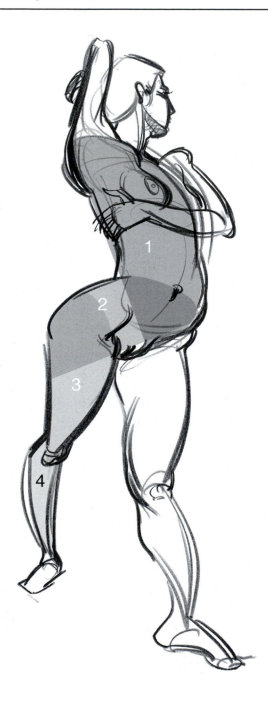

The road of rhythm is created by the overlap of forceful shapes from one to four. Shape one is our first in the pyramid, explaining the majority of the body. For depth, notice the size difference in her feet.

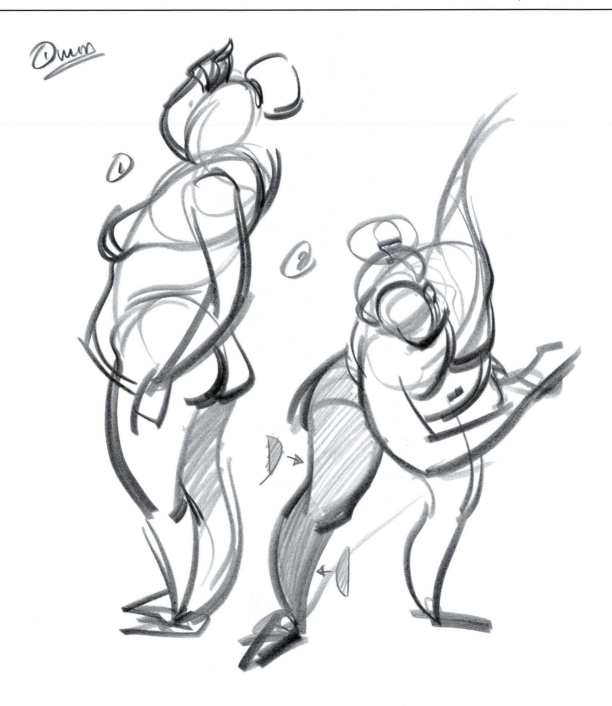

Here are some fast drawings that show the efficiency of using shape. Shape along with some overlap gives immediate form. The leg has straight to curve and the knee overlapping the shin give the leg structure.

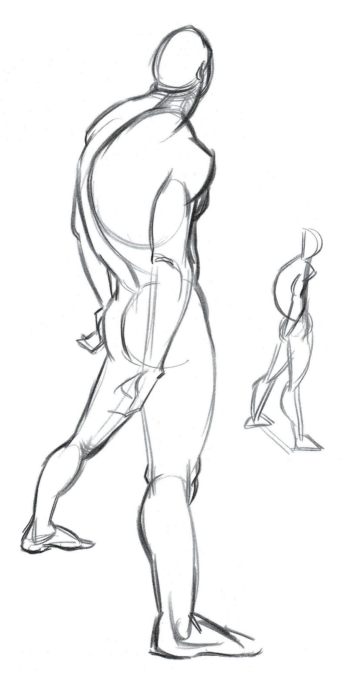

Look at the extremeness of the pose. See the straight of the chest relative to the curve of the back. We can see a smaller representation of this in the model's arm. The straight to curves move us from the deltoid to the triceps to the forearm and into the hand. Also notice the size difference in the feet for depth. See the thumbnail for clarification.

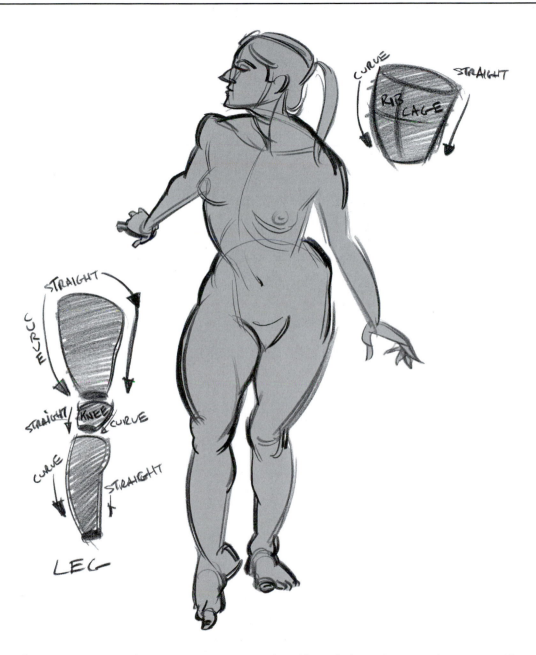

This silhouette gives us a clear contrapposto pose, the oblique balance between the torso and hips. This originates with the straight to curve of the upper body. We can see the plane of perspective she is standing on because of the location of her feet relative to one another. Look at the straight to curve shape of her left hand and the size difference between both hands. This implies depth. Her facial profile gives us the direction that her head is pointing in. I also reveal the design of her right leg. See how it is structure that creates the shapes.

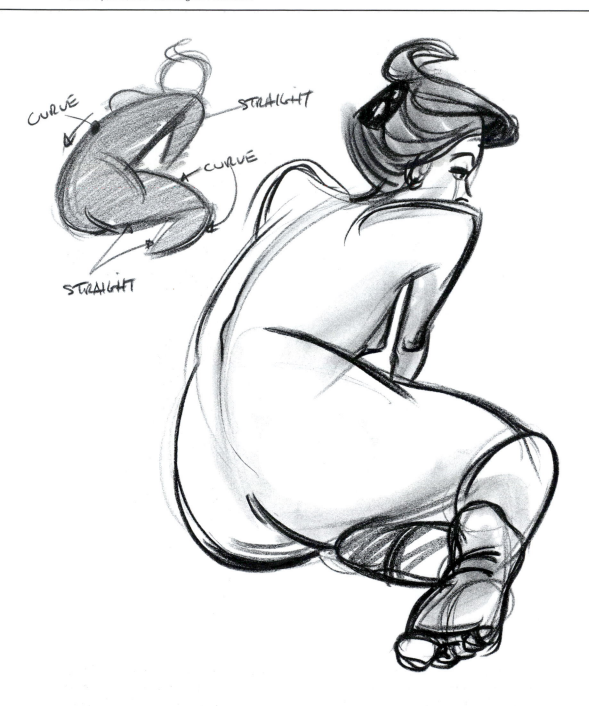

Mike Roth's drawing has simplified the body into the straight to curve shapes. Look at the back relative to the front of the ribcage. The right arm and leg are other good examples of this theory. The fluid hair shape is fun, too. See also the size effect of the foot here.

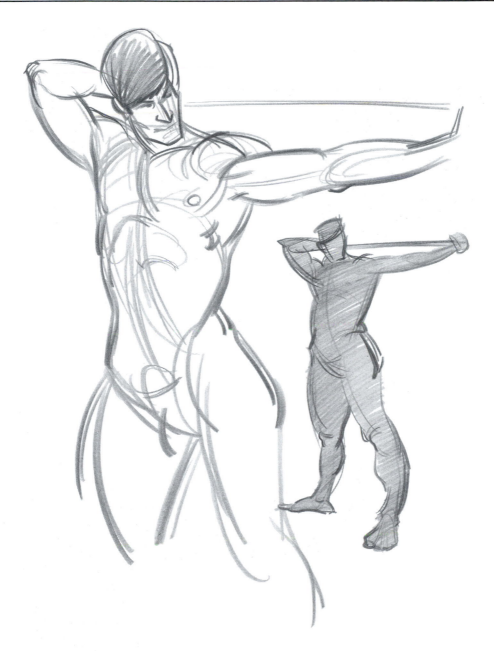

In this drawing, let's look at how straight to curve strengthened the story of the pose. The curve of the front of the model's ribcage and belly is not strong enough in the large drawing. He weakly leans to the left side of the page. Through seeing silhouette and the concept of straight to curve, I strengthened the push of the back into the belly with the straights in the upper back and hips. This helps the clarity of the rest of the pose as seen in the thumbnail. I like the strong curve of the left arm pulling on the belt.

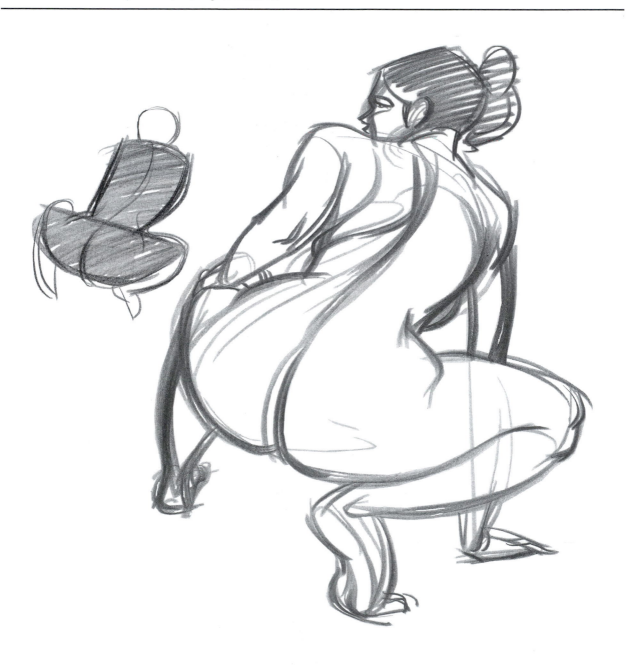

The largest example of forceful shape is her upper body. The left side is the straight and the right is the curve. This drawing is full of stronger against weaker curves like the one in her right foot. This same shape appears again in legs, arms, and the fold of skin that wraps around her ribcage. Also, there is a subtle straight that runs from one knee, through her hips, across to the other knee with the bottom of her butt be the curve.

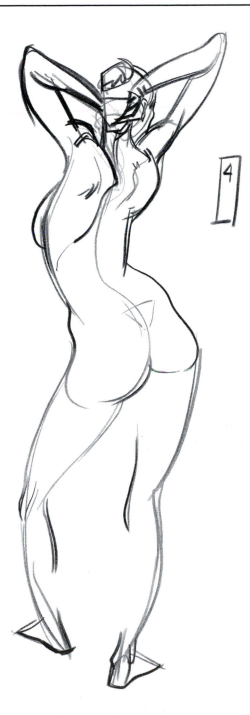

The vertical straight line found in the back supports the long, outward thrusting curve of the ribcage found along the perimeter of the left hand side of the drawing.

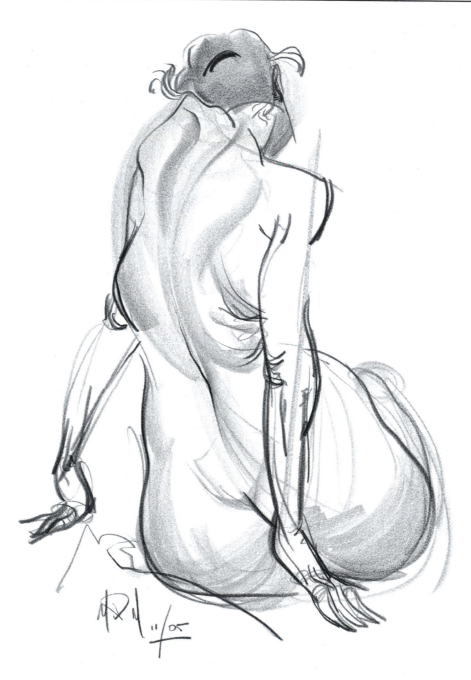

This experience was exciting in combining force, form, shape, and some texture. Remember to see the big straight to curve ideas of the body to create a more forceful silhouette. You can see the straight line I thought about going down the right side of the body. That helps us push the curve out on the left.

ANATOMY AS SHAPE

Forceful shapes can get more specific. I want to discuss some powerful theories about the anatomy of the body that pertain to force and rhythm as seen by forceful shape. The body, as I said earlier, is built to move. Its musculature is set up in traverse angles from one area in the figure to another. These relationships allow it to perform. If you work out or you are a physical therapist, you know exactly what I am talking about. The biceps are opposite in function to the triceps. The biceps bring your hands to your shoulders and your triceps help straighten your arm.

In the following drawings, we will travel from simple to complex depictions of the power of the human form through forceful shape.

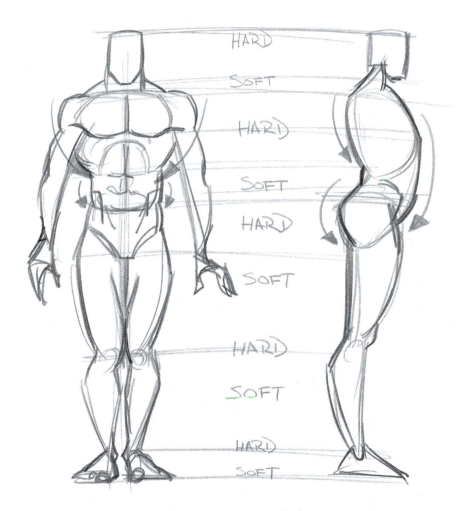

Here I want you to see that, as a whole, the body looks symmetrical. Because of this, the torso of the figure feels rigid. Its left and right edges are a mirror image of one another, causing forces to collide

(as the arrows show). The torso does not work from left to right, but from front to back. It is in the torso's profile that we see how this complex organic entity is built to move and operate.

At this time, I also want you to be aware of the fact that the body is built in a hard bone and soft muscle pattern. The head is hard, neck is soft, ribcage hard, abdomen soft, pelvis hard, thighs soft, knees hard, calves soft, ankles hard, and the bottom of the feet are soft. The soft areas are what make it possible for us to move the hard ones.

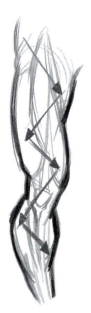 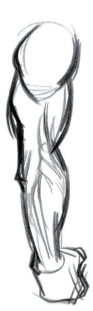

The limbs of the human body, although always paired, have asymmetry within themselves. Look at the drawing of the leg. Look at how its musculature creates asymmetrical forms and therefore a functional and appealing shape. The same goes for the drawings of the arm. There are no moments of mirroring or equal forces being found on both sides of a shape. The shape of the body's anatomy always gives us a feeling of functionality. A simple way of seeing this is to notice the peaks of force on the sides of a shape and making sure that they are not directly across from one another.

J.C. Leyendecker was the master at putting everything we have discussed so far into his work. He was an illustrator from the earlier part of the twentieth century. His work shows decisive shapes that are full of force and form. They are created with clear straights and curves. There is no laziness in his

work. Leyendecker would have been a great character designer had he been alive today. I strongly suggest looking at his work. It is difficult to find much of it. There is a poster book called "The J. C. Leyendecker Collection: American Illustrators Poster Book" that is available for sale. There is also an older book that is extremely rare, but full of his paintings: "J.C. Leyendecker" by Michael Schau.

Dean Cornwell is another artist from this time period. I would like to make you aware of him before we move on. His forceful design is not as strong as Leyendecker's, but he is powerful in the area of structure. His work leans towards straighter, harder moments. He also has some great definitive shapes in his work. There was also a book published on his work called "Dean Cornwell, The Dean of Illustrators" by Patricia Janis Broder.

The theory of straight to curve allows you more exaggeration, clearer opinion. Make a statement with every shape.

"Exaggeration, the inseparable companion of greatness."
Voltaire

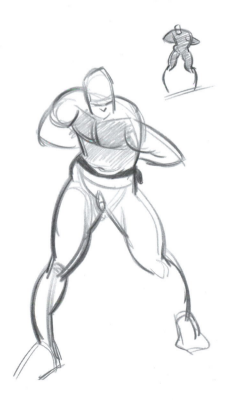

Here you can see the exact example of the asymmetrical legs at work. Look at the straight to curve of the ribcage, the hips, shoulders, and arms. Notice the apexes of force and their asymmetry. Look at the thumbnail for straight to curve silhouette.

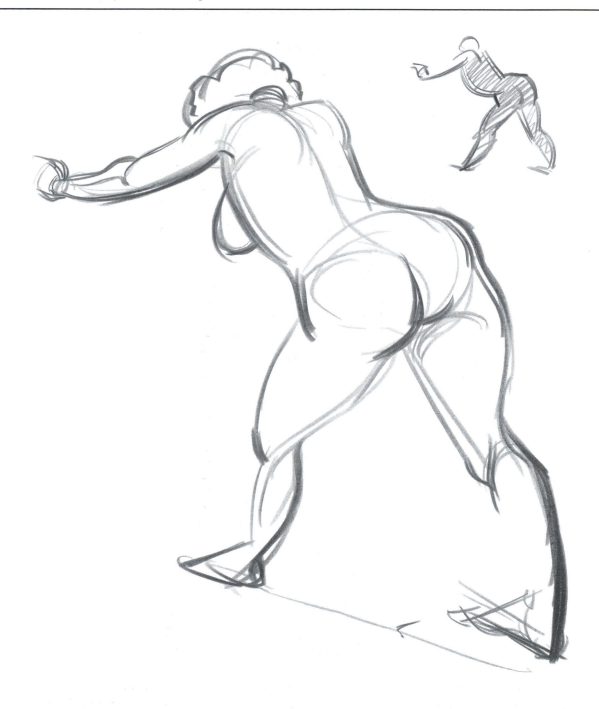

The clarity and understanding of this pose epitomizes all levels of drawing, force, form, and shape. Its simplicity is what makes it so successful.

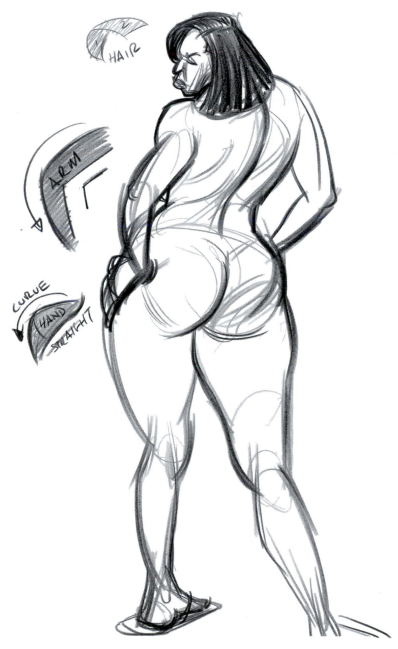

I love the sense of thickness conveyed in her back and buttocks by the curve in those areas.
See the small straight of her ribcage to define structure. Look at the asymmetry found throughout.
The simplicity of straight to curve of her left arm gets the idea of force and form across. Notice the
structure of her head and the shape of her hair. Lastly, look at her left hand and how it also has
straight to curve or forceful shape in it. The knuckle line gives the flat shape its structure.

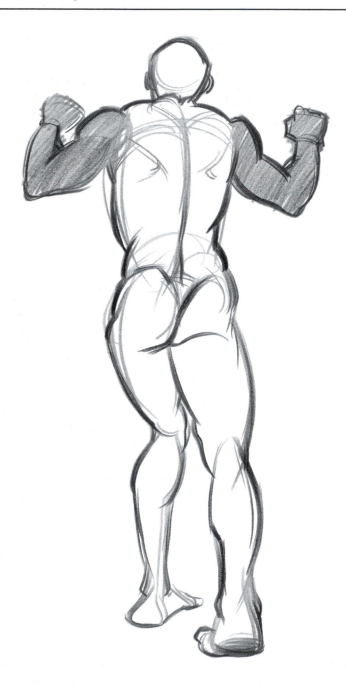

Definitive lines show us a lucid understanding of the forces and forms of this model's pose. Look at the asymmetry in the arms and upper body. See how the structure of the back created its shape.

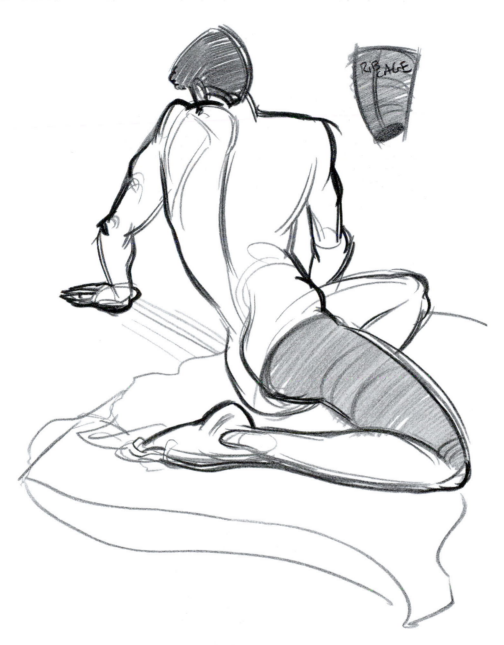

Look at the efficiency. This pose is complex in its idea. The model is turning over his left hip and sustaining this torque with his left arm. His right leg is closest to us and is also under a certain amount of tension, caused by the rotation of the upper body. The model's figure consistently moves away from us in space. See the subtle references to depth in the overlap and the light structural lines. I enjoy the quiet reference made to the left shoulder blade and how it relates to the operation of that shoulder. I reveal the forceful design of the ribcage and right thigh.

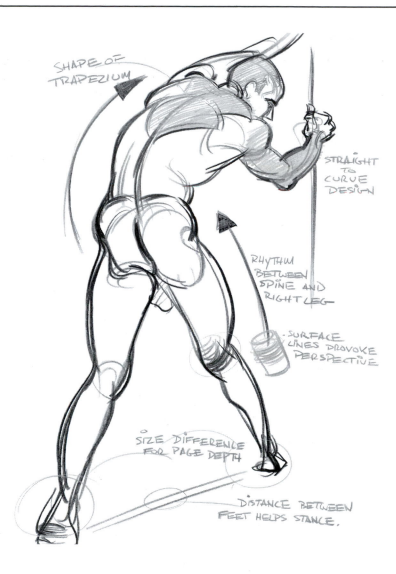

SHAPE OF
TRAPEZIUM

STRAIGHT
TO
CURVE
DESIGN

RHYTHM
BETWEEN
SPINE AND
RIGHT LEG

SURFACE
LINES PROVOKE
PERSPECTIVE

SIZE DIFFERENCE
FOR PAGE DEPTH

DISTANCE BETWEEN
FEET HELPS STANCE.

I love the power of this drawing. It is opinionated. It tells us what the model was doing, loud and clear. Look at the shapes created by the anatomy and how much force they imply. His right arm and buttocks are two unmistakable moments of this. See the structure in the straights and the force in the curves. His silhouette can be easily understood. See how his legs work relative to the torque in the upper body.

Line has no form; shape does. In this chapter, force has been described in the rules of straight to curve. That led us into asymmetrical anatomy. Lastly, to modify everything into successful shapes, we turned to the silhouette. Its clarity is as strong as a magnifying glass in looking at all of the preceding concepts. Here you can see if everything is working successfully.

REACTION, THE LEAP OF FAITH

A great deal of drawing is academic, but what finally gives it power is your reaction to the reality in front of you. This reaction is pure opinion relying on academic knowledge. Reacting means you don't have time to copy. You go after full concept and feeling. The more you learn how to draw, the clearer and more powerful your reactions to the figure will be.

It is time to have faith in your abilities. Put yourself out on the line, take the leap of faith, and fearlessly enjoy your experience with the model. Give the drawings some of your heart. With the closing of this half of the book, I want to share with you some drawings that express my exhilaration in drawing the model.

Shorter poses are a great way to force yourself into reacting.

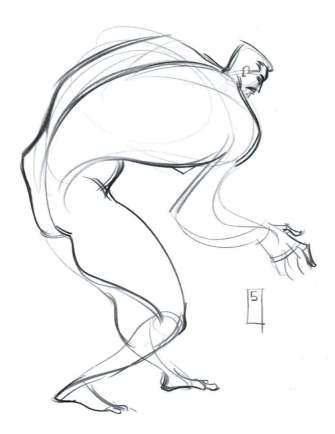

My opinion here was, Wow, look at how immense his upper body is. His feet are so flat and thin. I enjoyed the fluid quality of his arm and thickness of his leg. These moments are all ideas that occurred in my initial reaction, ideas which I stuck to instead of getting caught up in copying the model.

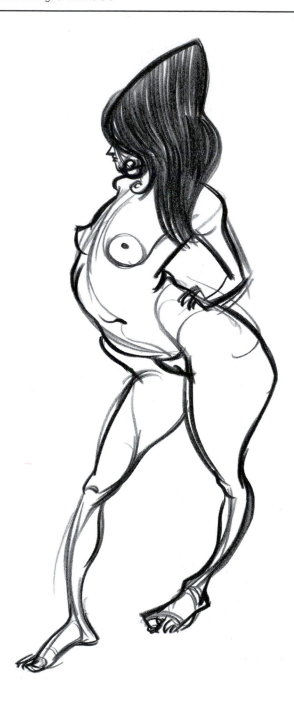

Sloped head, extreme pose, and thin legs are just some of the reactions I had to the model in this pose.

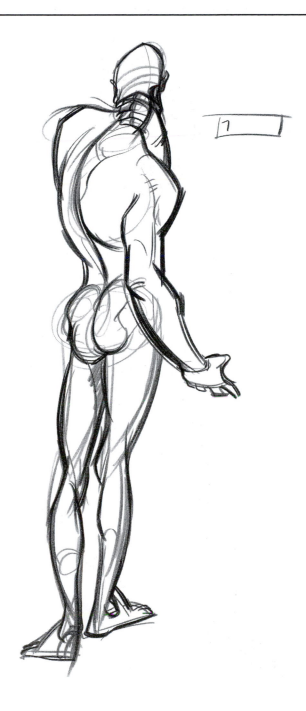

Here I was going for the model's thin legs, massive shoulders, and upper body. The trick to this design is to keep it fluid.

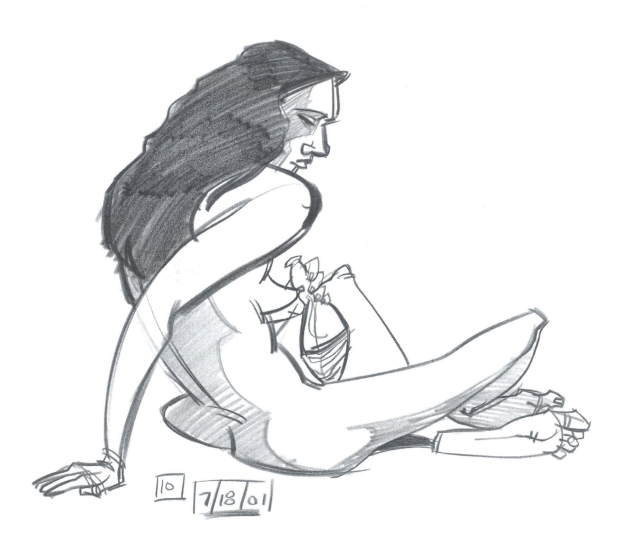

Long thin legs and feet are expressed here. The weight is on her buttocks and the force is in her right shoulder. The expression on her face has also been captured.

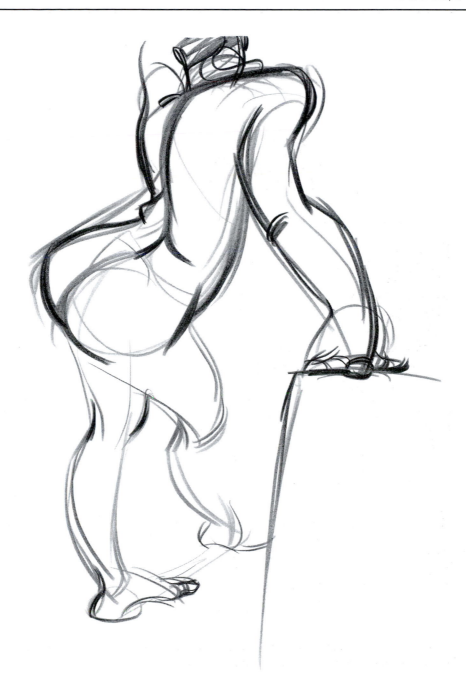

This drawing is a great example of forceful shape and playing with size for depth. Look at the fluid shapes from the close hands to the feet down on the ground and off in the distance. Efficient line and overlaps take us through space.

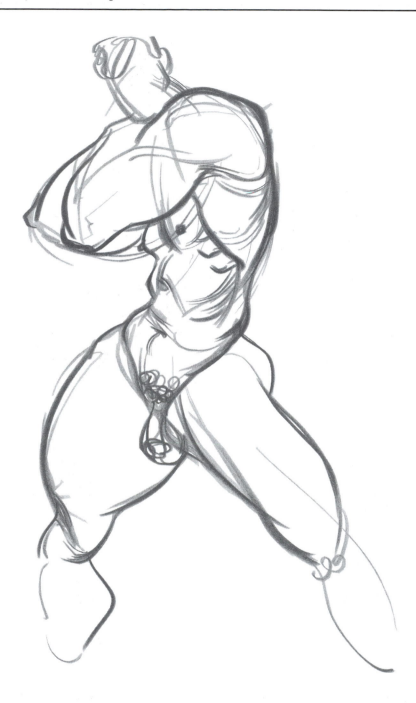

I love the cartoony musculature in this drawing performed by Mike D. You really get a sense of how much fun he had during this experience. Look at the fluidity, form, and shape.

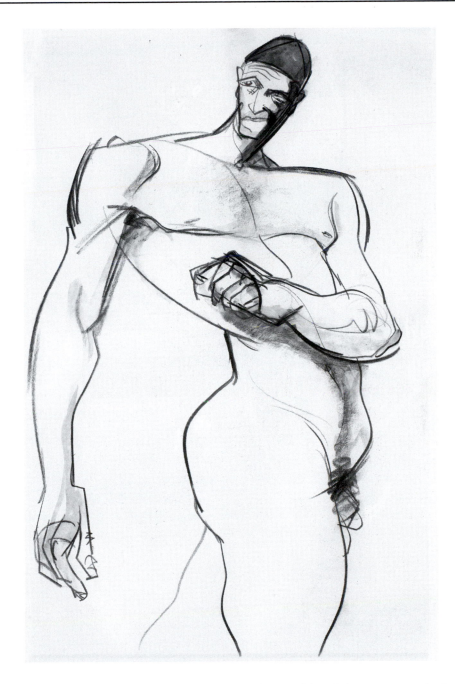

Flat, shape design supported the concepts in this image. The small head shape against the large chest along with the large hands, imply heroics. The strong curve of the back against the straight of the chest drive force down into the abdomen. A few simple anatomical centers like the sternum and the navel fill the shapes of the upper body with structure.

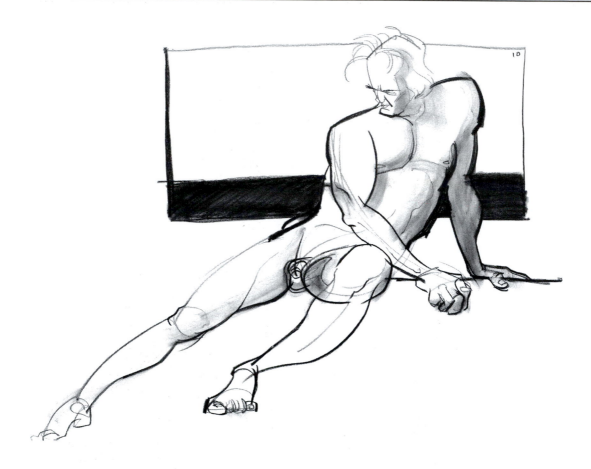

Here is another entirely different story. It was a godlike quality that I was after. The massive shoulders, large hands, and crazy hair make for an interesting statement. Notice the lack of under drawing. Each opinion about the model is expressed as I reach it.

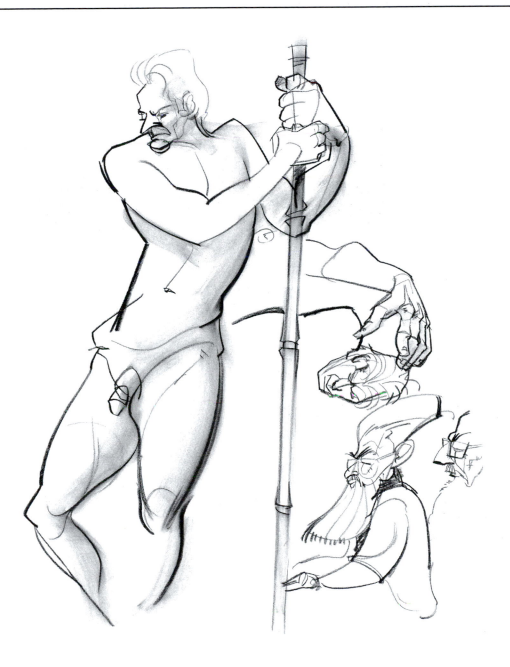

A crazed, angry old man with a short neck and long torso were thoughts that occurred to me during this pose. On the right, a fellow artist is hard at work.

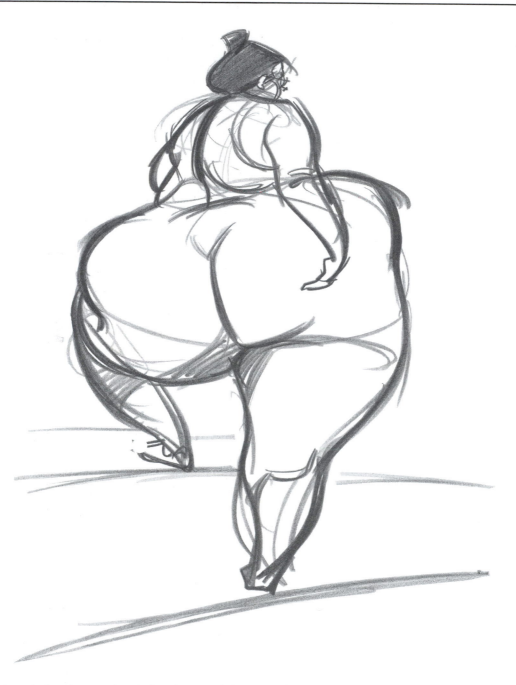

Yes, there is the obvious, but I also shortened the upper body and size of her head to push my ideas.

These last few drawings are our wrap-up for the first half of the book. They also introduce us to the next chapter. Look at the texture of line in these drawings and how it affects the story of each pose.

All processes combined. The following drawings show how force, form, and shape all make their appearance in drawing the model.

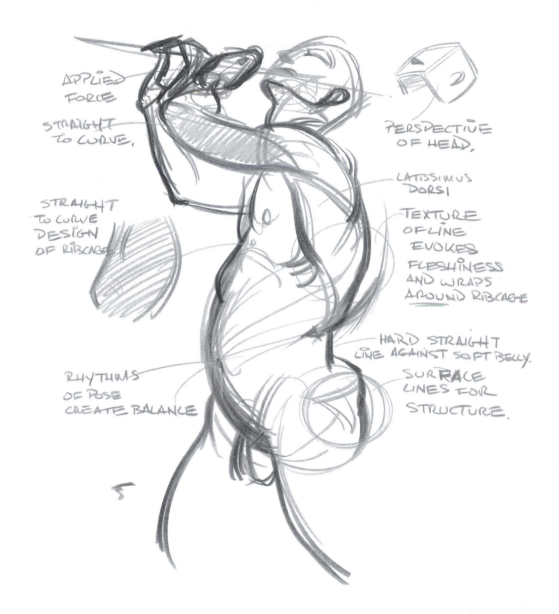

APPLIED FORCE

STRAIGHT to CURVE.

STRAIGHT TO CURVE DESIGN OF RIBCAGE

PERSPECTIVE OF HEAD.

LATISSIMUS DORSI

TEXTURE OF LINE EVOKES FLESHINESS AND WRAPS AROUND RIBCAGE

HARD STRAIGHT LINE AGAINST SOFT BELLY. SURFACE LINES FOR STRUCTURE.

RHYTHMS OF POSE CREATE BALANCE

I love the graceful flow that brings us up from the belly through the back and shoulder into the left hand. The fleshy lines let us enjoy the model's muscularity. See how the small hard straight of the lower back is enough to give us strength between the ribcage, belly, and hips.

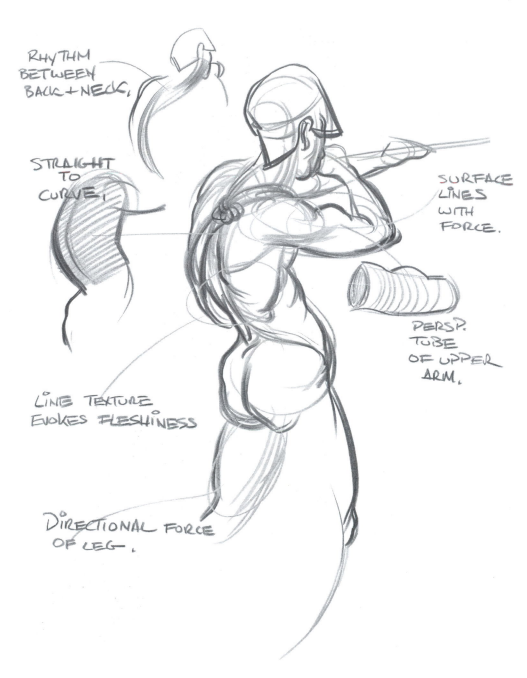

RHYTHM
BETWEEN
BACK + NECK.

STRAIGHT
TO
CURVE.

SURFACE
LINES
WITH
FORCE.

PERSP.
TUBE
OF UPPER
ARM.

LINE TEXTURE
EVOKES FLESHINESS

DIRECTIONAL FORCE
OF LEG.

Look at the wide variety of ideas expressed. Of course there is force, form, and shape, but beyond that, the variety of line pressure brings us closer to the reality of the model. See the hard point of the shoulder blade against the meaty thickness of the latissimus dorsi. See how specific you can get about a model without losing your sense of the pose's rhythm.

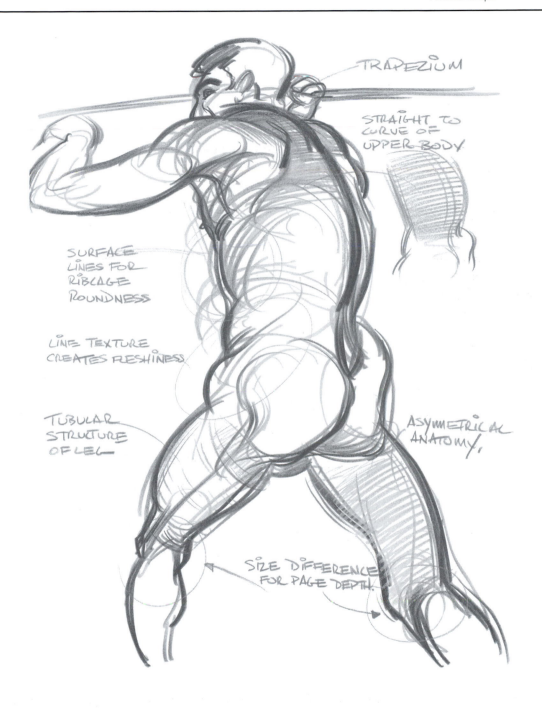

TRAPEZIUM

STRAIGHT TO
CURVE OF
UPPER BODY

SURFACE
LINES FOR
RIBCAGE
ROUNDNESS

LINE TEXTURE
CREATES FLESHINESS

TUBULAR
STRUCTURE
OF LEG

ASYMMETRICAL
ANATOMY,

SIZE DIFFERENCE
FOR PAGE DEPTH.

So here we see force, form, and shape again. Notice that the relationship in size of the knees gives us depth.

FORCEFUL SHAPE POINTERS

1. Stay aware of the rules of forceful design. See abstract straight to curve.

2. Go after your ideas.

3. See silhouette.

4. Think about the figure as flat shapes and then fill those shapes with structure.

5. Think of analogies as you draw.

6. Try drawing in two tones. Get down force and form first then use a second color to clarify shapes.

7. Have model create a character and moment for themselves. See if you can figure it out and draw it. Find out afterwards how close you came to the character.

8. Think about the history of the model to help you form opinion.

9. Draw model with all straights. Then apply one curve at a time to each new pose.

10. Cut out a forceful "D" shape (straight to curve design) from a colored paper. Adhere it with a glue stick to your newsprint relative to where you see it in the figure. (The first shape should be the ribcage.) Then draw the figure on top of the shape. During longer poses, find multiple shapes in the figure. This is an excellent exercise for seeing the abstraction of forceful design in the human figure.

Chapter 4
Clothing

THE TEXTURE OF LINE REVEALED

Let's talk about Michelangelo's Pieta'. What is so amazing about his sculpture is how marble is made to look like flesh, bone, and cloth. Yet of course, if you were to touch it, it would be cold and hard. Its shapes fool us into thinking otherwise. The long smooth curves invent flesh. If you were to accurately draw this sculpture, it would have to be with harder lines. When drawing a real human being, the shapes should be drawn with the amount of pressure on the pencil that most closely resembles the texture of what it is you are drawing.

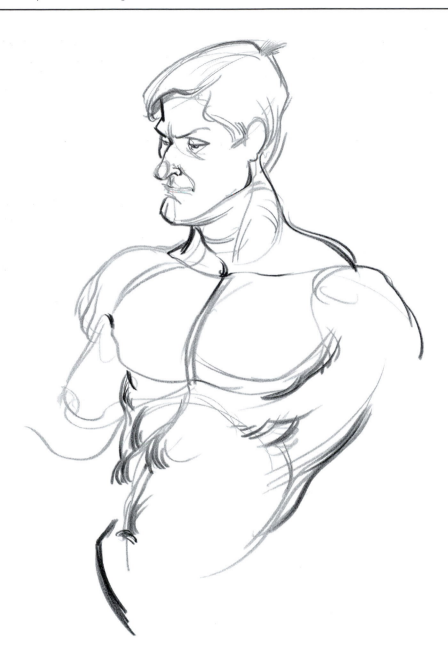

Above, look at the face next to the model's hair. See the sensual sculpting of his abdomen and the hard lower abs. Feel the hardness of the jawbone.

As you can see from the previous drawings, the pressure of the line I created them with established the hardness or softness of the subject I was drawing. A simple example about the application of this reality that I mention in class is if you were to draw a brick and a rose, you should draw them with two notably different types of line. The brick would be drawn with a hard, angular line while the rose would have soft, delicate curves.

Drawing fabric is a great way to experience line's ability to express texture. Most fabric feels different from skin and bone. This gives us a great contrast to experience.

Fabric has no form; it is like paper, thin and flat, without energy. When something is done to it, it takes on different properties. Say we crumpled it. Then it would sit as a wrinkled mass with no function except that of the material itself, weighed down the force of gravity. There is much information that can be collected from it at this stage. The softness or hardness, thickness or thinness, can be recognized by the formation of the wrinkles. As soon as we hang the cloth on something, the weight of the material comes more clearly into play. Look for this information in the following drawings.

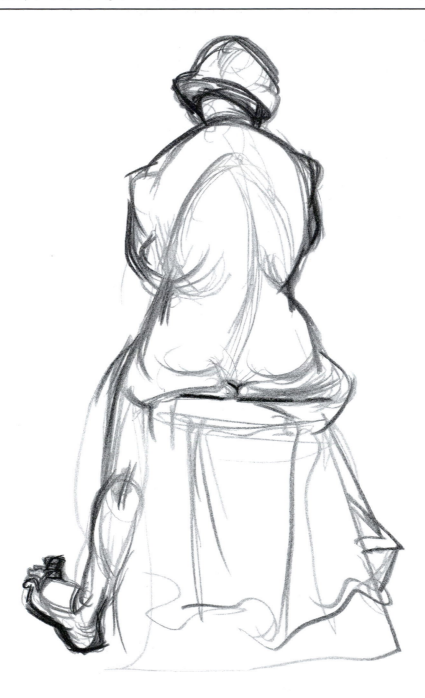

Mary Ellen's drawing is full of texture. See the hard, curious foot and the straight line of pressure of the buttocks on the stool in comparison to the curly, flowing material hanging from it.

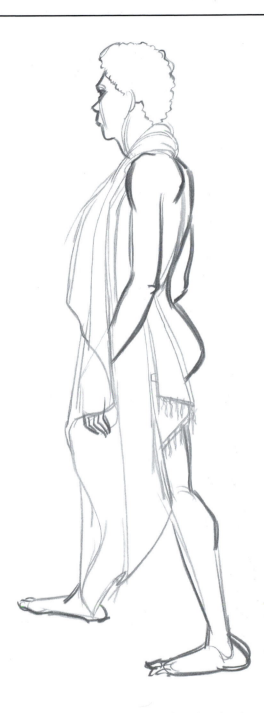

Here we can tell that the material is thinner and yet somehow harder than the last. It folds in angles and straighter lines. You can see this around the neck where we also see how clothes can begin to describe form. I like the texture of the strings hanging from the material.

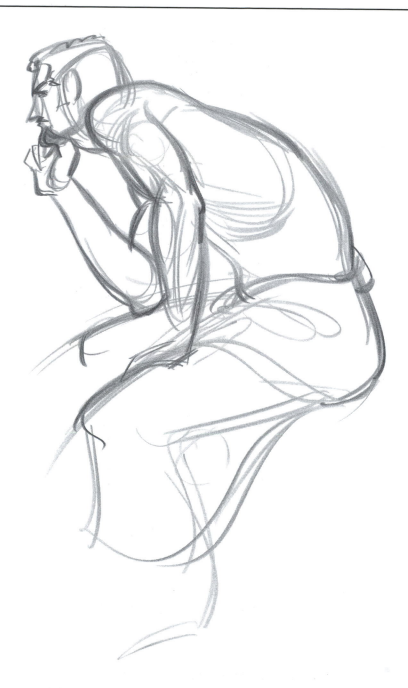

The hardness of the ribcage, left shoulder, and elbows against the soft, flowing material wrapped around the model's waist gives us a great variety of sensations. See how the type of line, the way it curves, and the pressure I used to draw it tell us about its weight and feel. The fabric is heavier and thicker than the previous.

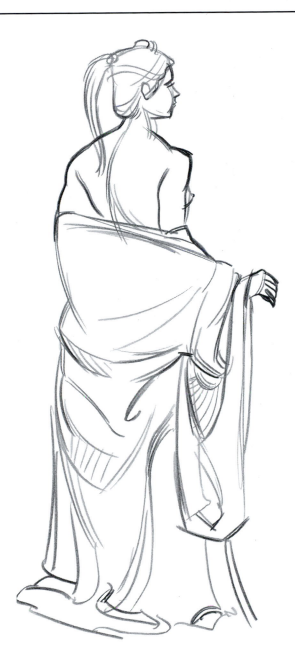

The model's long, wispy ponytail stands out against the solidity of her face and figure. The fabric is slicker and harder than the others. The wrinkles are pointy and change direction aggressively. Look at how the robe wraps around her arms and then hangs from the right wrist. I like the small, hard, straight line that represents the bottom end of the cuff.

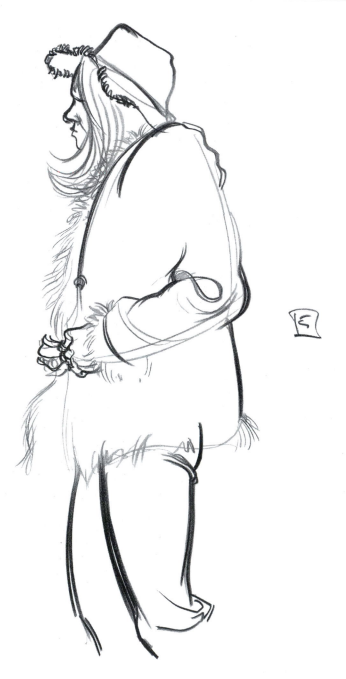

Look at the variety of marks to describe texture here. The hard crunchiness of the hat's brim, the soft fluidity of her hair, the heaviness of the jacket and jeans next to the light fur of the jacket edge.

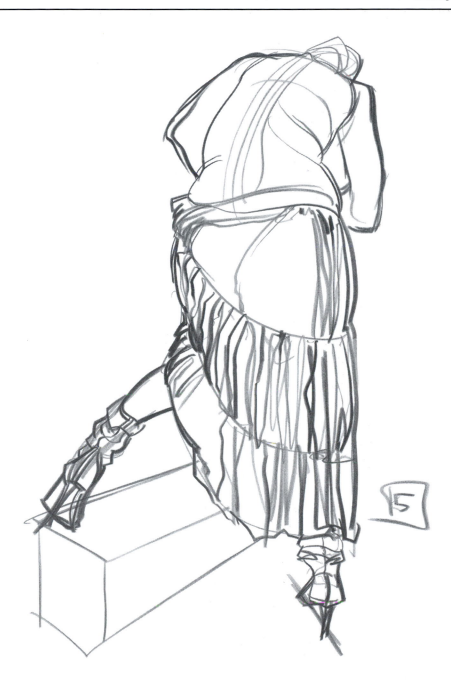

In this last drawing focusing on texture, feel the crumpled quality of her dress against the tight top and the leather of her boots.

THE FUNCTION AND FORM OF FABRIC

Everything we have learned so far has prepared us for the next step: drawing the model clothed.

The first thing to remember when drawing the clothed figure is that you are drawing a clothed figure. You must understand a figure's actions and anatomy before you can tackle the issue of clothes.

Fabric now takes on the forces and form of the person wearing it, thus making it clothing. Clothes hang on us, usually from the shoulders and the waist. Paying attention to the moments from which clothes hang is most of the story when it comes to drawing clothes.

Clothes can be a quick read as far as what the body underneath is doing. For example, if someone in a shirt were to bend over, you would see crumpled cloth around the stomach and stretch over the back. This is a symbol of the simplicity of the figure's function. The same phenomenon can happen in a smaller moment, like a bent knee or elbow.

The other major attribute of clothes is the fact that they wrap around the form of our figures and have holes to suit the way our bodies are built. Look at collars, waists, and sleeves, and also don't forget the seams where the clothing has been stitched together. These examples can help you describe the figure's form.

When first confronted with drawing the clothed model, I find it wise for the student to first find the function and form of the model. Then draw the clothes and notice where they hang from. See how the story the clothes show you relates to the forces of the pose. In the beginning, draw all of the wrinkles you observe. This will more quickly make you realize how clothes work.

A couple of books I can recommend on the subject of clothing are "Dynamic Wrinkles and Drapery" by Burne Hogarth and George Bridgeman's "Complete Guide to Drawing From Life." Hogarth's book is good in that he explains clothing in a directional force oriented method. He shows different types of wrinkles and pulls in clothing. The problem with this book for animation is that he draws all of the wrinkles and therefore the illustrations are too busy. You don't want to get caught up in doing this yourself. Clarity of the idea of the pose is what will make your drawings strong and loud.

Bridgeman describes different types of folds in the back of his book. They also are good to know. I believe that in the end, your observation and understanding of what the body is doing will help you achieve more believable clothed figure drawings.

Here is a recap of ways to approach the clothed figure:

1. Recognize the type of material you are drawing. Different materials wrinkle in different ways. Their breaking points vary and the kind of line you draw them with can express their texture.

2. I look at how and where on the body clothes hang from. Find the point, i.e., the shoulders, waist, or knees.

3. Always use the exits and entrances of clothing to help define form. I'm talking about the collar, sleeves, waist, etc. The stitching is just as useful. Look at where sleeves are attached or how pants are put together.

4. See the simplicity of stretch to compressed. Clothes can quickly tell you what is happening.

Leyendecker and Cornwell were both excellent at drawing clothing.

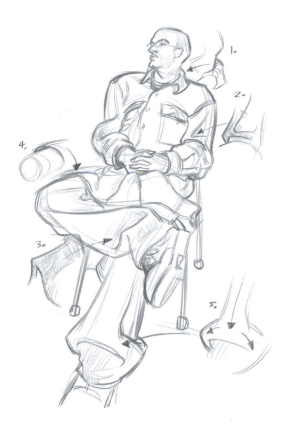

This drawing has examples of everything I discussed earlier. Force and form create the moments.

1. Here we see the thickness created by the fold in the shirt's collar. This gives us a sense of the stiffness of the material. Also see how the collar wraps around the model's neck to show form.

2. Look at how the material drops down from the shoulder and locks into a thick wrinkle that wraps around the arm.

3. The thickness of the pants is greater than that of the shirt as shown here.

4. The bottom of the shirt wraps around the form of the leg.

5. The weight of the jeans shoots down the leg and splits because of a locked fold near the ankle.

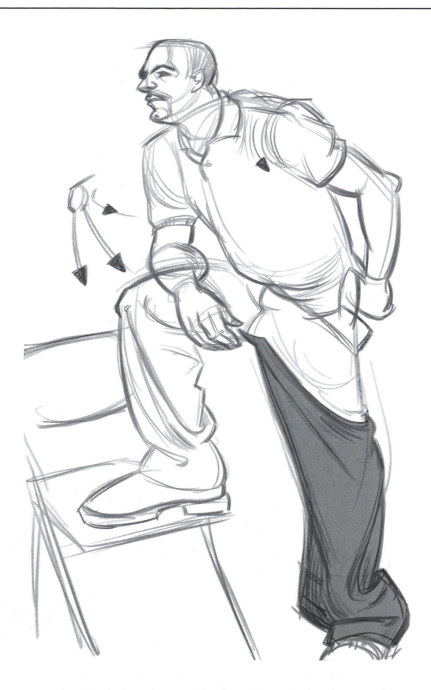

This is a great example of finding evidence of the figure through the clothes. Look at the model's left leg. See how the filled shape falls and hangs from the structure of the leg. His right knee shows the pants creasing away from it and down towards the ankle.

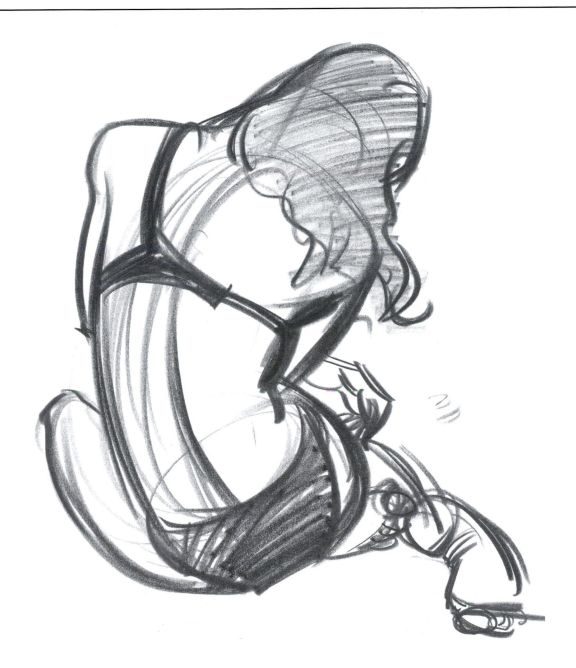

So here we have a simple example of clothes wrapping around the model's forms. Look at the different ellipses and how they determine the specific volumes and angles in the perspectives they reside in.

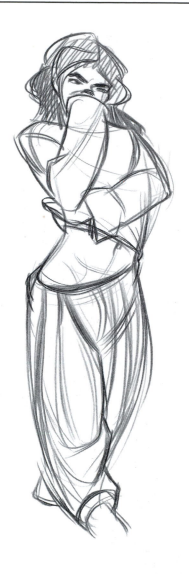

Look at how the clothes wrap around the model's body in this drawing by Mike Roth. The curve of the shirt and that of her pants tell us how her body moves in space. See how the pants lock into a wrinkle because of the downward force of the knee. He uses straight to curve in the sleeves and in the right leg. The leg has a curve to multiple straights.

In time, you want to be able to simplify the confusion of clothing. The ideas you draw from the clothing need to support the idea of the pose. You must learn to draw what the idea of the pose needs and delete what hinders it to keep the drawings animated. Here are more efficient and clearer drawings:

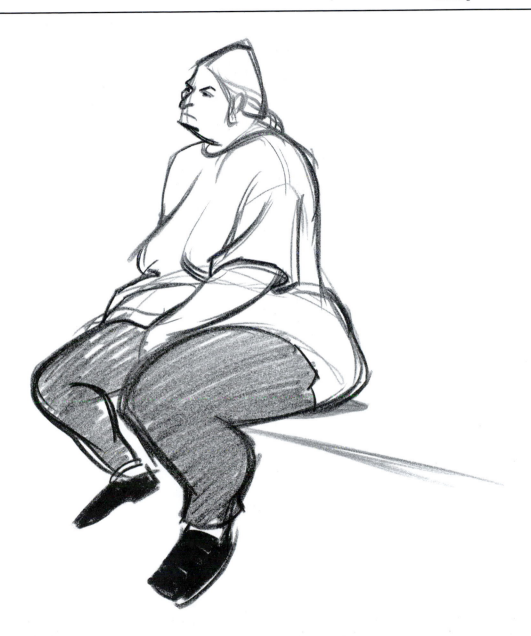

The neck hole of the shirt defines the form of that area. See how it hangs from her shoulders over her breasts. The sleeve of her left arm tells us her arm is coming forward by the overlap in the wrinkles and the elliptical shape of the sleeve opening. Look at how it drapes over her legs, revealing their roundness.

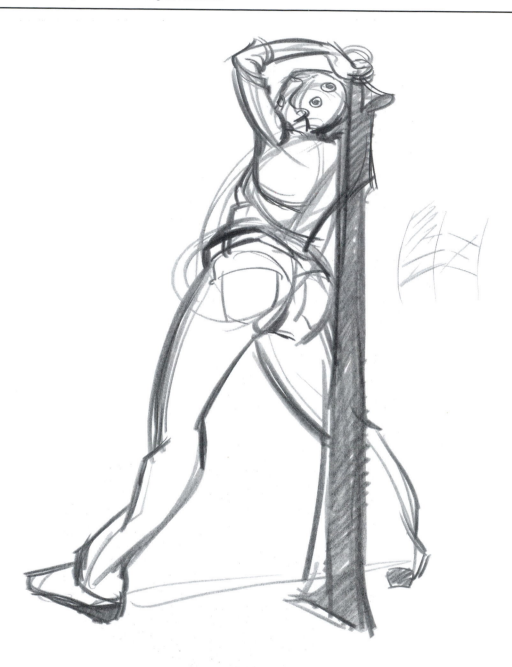

Here we can clearly see how the model's belt describes the angle change between the side of her hip and her back. The roughed-in pockets also help describe the roundness of her buttocks.

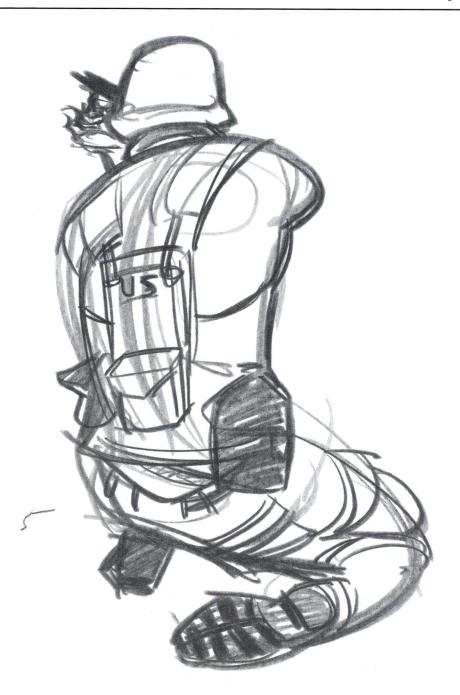

The backpack here is a great tool for describing the direction in space of the back. The pockets on his right leg show us its roundness of form.

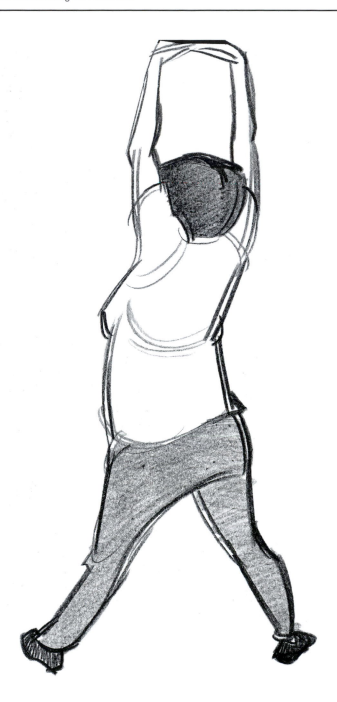

This drawing really gives a great sense of stretch in a highly efficient manner. Look at the straights and curves of her legs. The lines that describe the wrinkles around her back and left knee give us form.

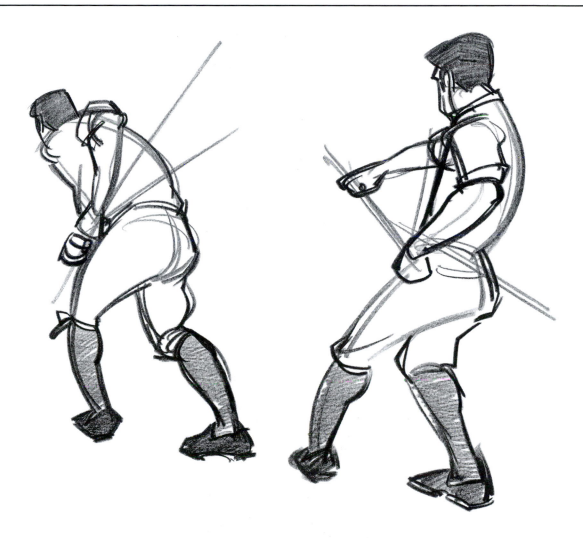

Let's return to drawing small and thinking big. These two drawings could be animation keys. Both show straight to curve in the upper body. See how that force is balanced with the strong curve of the left leg in the left drawing. Notice the minimal approach to the wrinkles in the model's costume. The drawing on the right has more information about the clothes. See the stretched fabric near the left knee, or how it is compressed in the right.

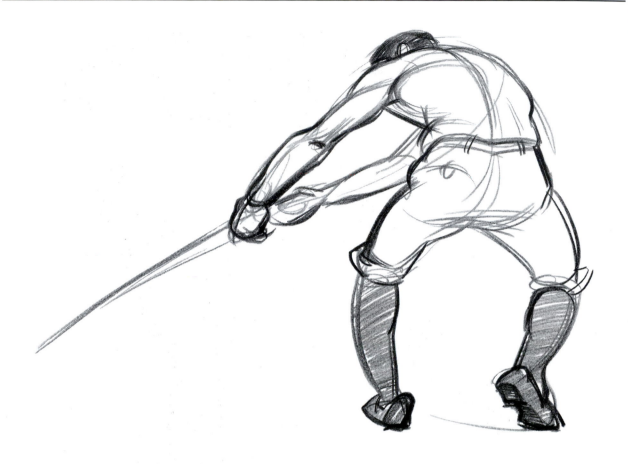

I love the clarity of this drawing. Obviously having a great, hard working model really helps also. See how the stretched triangular shape created by the arms and the back works against the pressure of the left leg. There is evidence of this in the way I treated the shoe. The back left pocket helps define form.

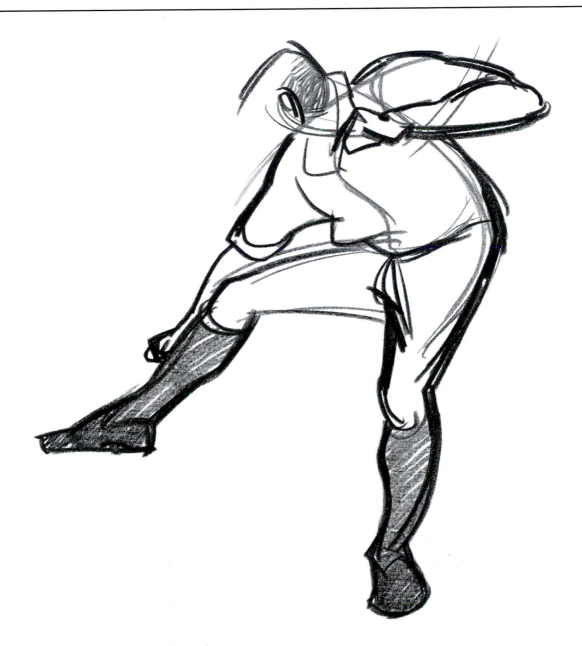

This drawing has the shirt crumpled on one side and stretched on the other to give you the concept of bending over.

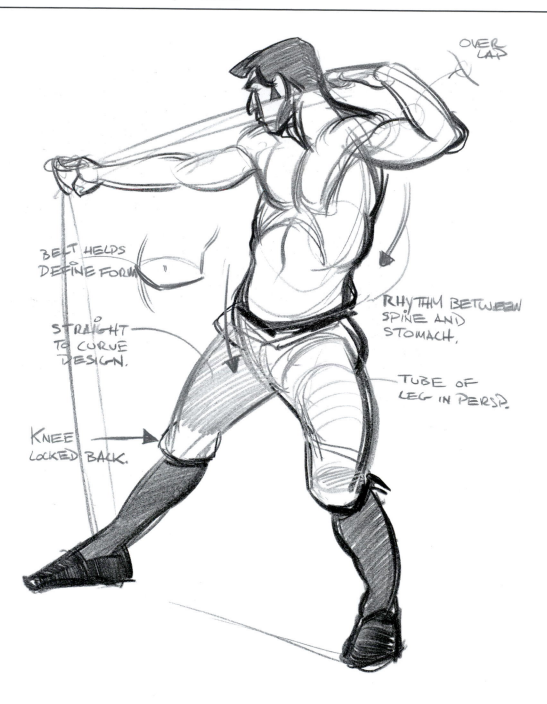

OVER LAP

BELT HELPS DEFINE FORM

STRAIGHT TO CURVE DESIGN.

KNEE LOCKED BACK.

RHYTHM BETWEEN SPINE AND STOMACH.

TUBE OF LEG IN PERSP.

Another great pose. To discuss line quality a little more, I feel the upper body comes across as flesh and the lower as cloth. See the distinctive idea of each leg and its structure. The model's right leg has a sense of the knee being locked back. The other is all work in the quadriceps.

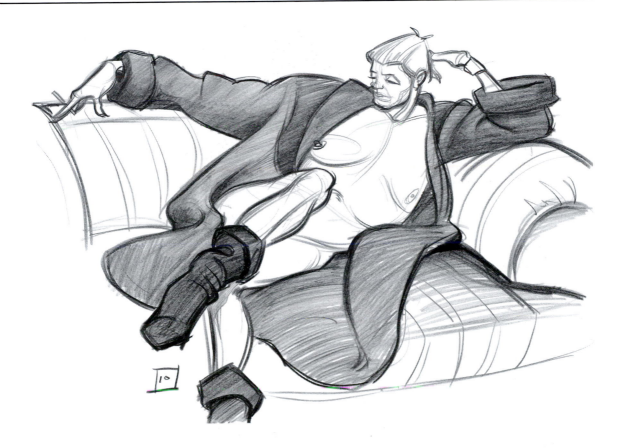

Here the long soft curves of the coat help us understand its texture. The difference in the curves of the boots explains its fabric.

FUN WITH SHAPES

Clothing offers us more shapes to play with. This means new inspirations for describing the specific model and story of each pose.

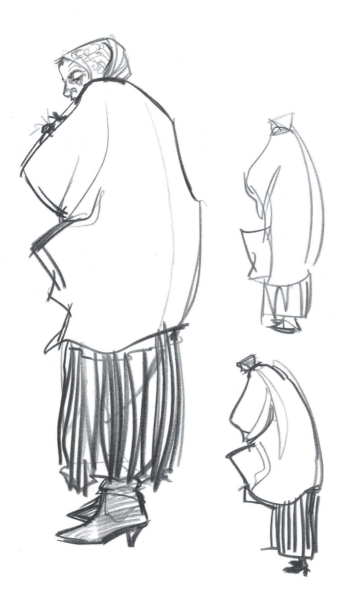

This drawing and the next are a great example of contrast in story. Above we find the meager, downtrodden, old peasant woman. Here her jacket engulfs and protects her from the outside world.

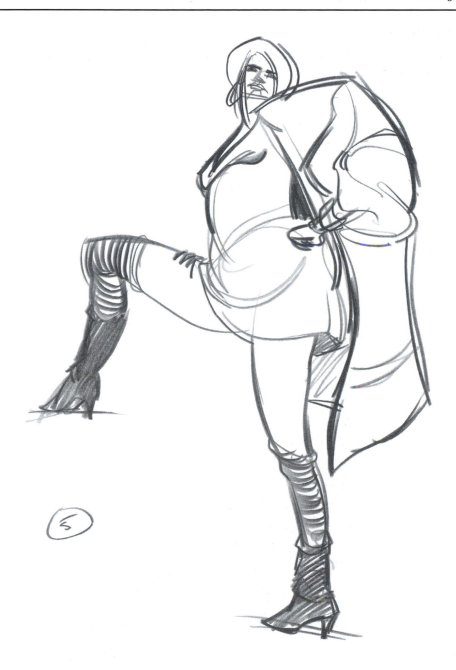

Here the same model shows us a woman with strength and confidence. The large shape of the jacket seems to support this idea.

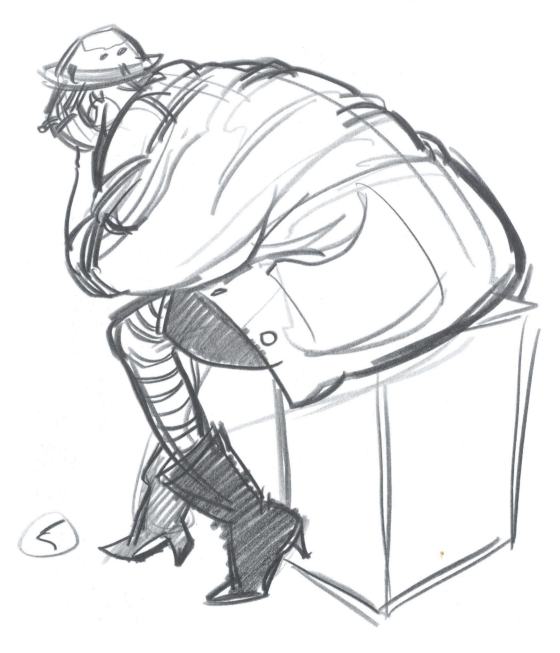

The main play in shape here is the size of the jacket against a small head and thin legs. These elements still help to give us an interesting character.

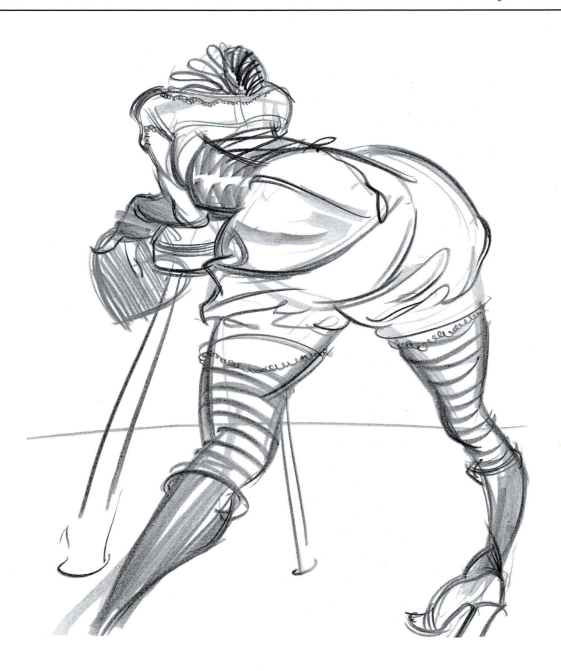

In Mike D.'s drawing, shape lends itself to the depth of the page. The model's head recedes into the page and we feel space between the knees because of their difference in size.

I want you to realize that clothing is not only a topic you should understand technically. Clothing can tell a story. When drawing people, ask yourself some of these questions: What kinds of clothes does this person wear? What color are the clothes and what kinds of materials are they made of? Are the clothes snug or of a more relaxed fit? All of this gives you inside information about a person. It starts to give you a personal story. Notice yourself and figure out why you wear the clothes you do and how they represent you.

"Know, first, who you are; and then adorn yourself accordingly."

Epictetus

FORCEFUL TEXTURE POINTERS

1. Become aware of the hard and soft areas of the body.

2. Think of clothing as having different speeds of force.

3. Be aware of the contrast in pressure of your marks.

4. Use clothes to clarify the concept and volumes of the pose.

5. In your mind, think about touching the model and the clothes they wear.

6. Remember how important clothes are in describing character.

Chapter 5
On Location, Reportage

TELL STORIES WITH LIFE

"Art teaches nothing except the significance of life."
Henry Miller

After going over drawing clothes, the next step is going outside with everything we've learned. Drawing on location, or reportage, can be the most adventurous drawing experience. Here you have the chance to report, as a visual journalist, about the world around you. See the stories of everyday life. "People watch." I find that if I write about what I experience, it helps me see the wonder of it all. This way I'm not just drawing for study, but for story.

All the world is a stage: someone reading a newspaper on a park bench, people eating at the mall's food court or shopping, bowling, sports events, birthday parties; the list is infinite. If it is difficult to go outside, draw from TV. Use DVDs or tapes to frame through people's motions. It's great for observing.

The biggest obstacle to overcome is the lack of time you will have to watch someone staying still. There will be a break-in period during which you realize how much you can study and are forced to put to memory in order to capture a moment. Remember that our objective here is to capture that moment, or your impression thereof. Focusing on being able to draw is for the classroom. You will not have time for that here. You have to trust your intuition. Let the simplicity of shape and silhouette make it possible for you to memorize more.

Our bodies express our thoughts. If someone is frightened, he doesn't stand with his chest pushed out. He cowers or puts his hands up to protect himself. A human symbol for triumph is having both hands raised above our heads with our fists clenched. It would never be bending over with your head in your hands. As I wrote in Chapter 1, realize that you can empathize with the people you are drawing. Use this connection to speed up your drawing process.

In class, the exercise students perform for story is similar to the hierarchy exercise I described in Chapter 1. I have a nude model figure out an occupation or story point that can be read through his or her body language. He or she takes a five-minute pose. Students write down what they think the model is expressing for the first minute. Then they draw the model with this story point in mind for the

last four minutes. This exercise is excellent for learning about the importance of body language, and also silhouette. In one class, the model took a reclining pose that clearly showed her scurrying away from an opposing force. The students behind her, though, who had an unclear view of the story, thought she was relaxing on a beach.

Another point I make to students is to go after character. People are so different from one another. As a side job, I have been doing caricatures since college. My clients always ask what feature I'm going to exaggerate. They look at me confused when I respond that I draw the forceful shapes of their head. I never pick a particular feature. I try and stick to my initial reaction, my gut feeling about the person.

Leroy Neiman is one of the few artists I know of that shows on-location drawings as part of his work. Most of you probably know him for his loud colored, impressionistic paintings of famous figures, especially in sports. His books have some great reportage drawings. The best one is "Leroy Neiman, Art and Lifestyle."

I also self published a book entitled "Reportage 01". Here you will find observations of New York City and Disney World.

Inner thoughts, outer reaction

Let's start with drawings of people thinking to themselves and trying to capture those thoughts. Here there is no outside stimulus.

Here is a typical moment captured by Mike. The upward lift of this woman's head makes it seem as though she is in casual thought. This woman is deep in thought; her burning cigarette shows us the progression of time.

Above are different people in different situations, all going about their lives.

Here is an observation about the train. Since I have been commuting for ten years, I have realized that people have come up with every possible way of ignoring each other in confined spaces. Walkmen, newspapers, magazines, computers, books, and closed eyes are some of the ways people have found to ignore their surroundings.

MAKENNA
8/24/05

So here is my daughter. Notice the casual stance of her body and yet how occupied she was with her hands.

Staging, single person

Something to be aware of in order to tell a story is staging. See what the relationship is between a person and something else. See the negative space between them. Look at the posture the person has relative to the object.

Mike Roth's drawing is an excellent example of what I want to see students achieve. We have the story of a man with a relaxed curiosity over the paper he is reading. Mike staged this very well. By giving us the negative space between the man and the paper, he lets us clearly see the moment. The silhouette is an easy read. The negative space in itself is a story. If it were greater or smaller, our story would be different.

I saw this as a moment between the player and the gridiron. He stands and contemplates the field.

In terms of a person's clothes portraying his character, Mike has revealed this man's cultural pride. Also see how the silhouette is a good read since the shape of the instrument breaks out of the shape of the man's body. The thumbnail in the corner does the same.

This is a drawing of my cousin Charlie helping his Dad cut the grass.

Here is a great moment with Makenna swinging by herself. All we need for story here is she and the swing attached to the ground.

Multiple moments

Drawing multiple moments of the same subject is more telling than drawing one. You will get a better sense of personality through the actions people take. This is also a great exercise for proportion and volume. This is a great time to use your VCR or DVD player.

I drew my niece Felicia on Halloween. She was a ladybug. What these drawings show is her urge to stand, along with her simultaneous inability to do so. Her costume made it easy for me to see her forceful shapes.

Here is Makenna and multiple moments of her playing on the ground with some toys. See how force, form and shape combined give us clear representations of story.

A friend is about to paint a wall, and it seems as though he hunches over to inspect it in the top left drawing. In the next moment, when he is painting, we see he stays hunched. This is probably a habit caused by his height.

If you have ever been on a swing, you know how to get it moving. It's all in the chest and legs, as this girl show us. Underneath the drawings I drew representations of how force would change in her body if I were to animate her. The exchange in force from concave to convex is exchanged through the rhythm or "S" curve in the center. That allows for a smooth transition in energy.

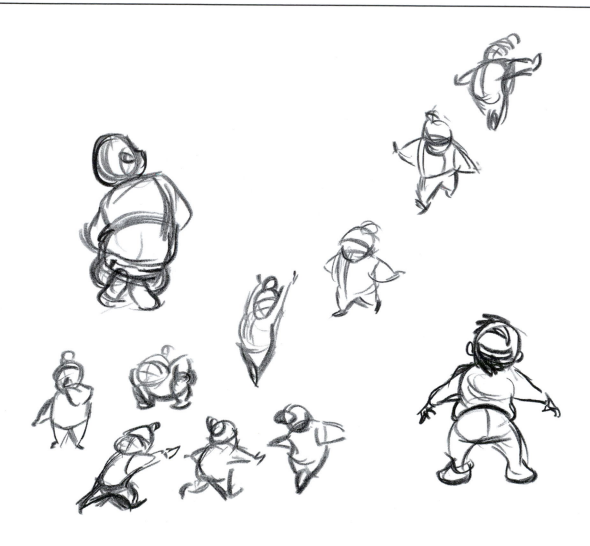

These drawings by Mike Roth are so much fun. Look at the simplicity of the shapes and how much squash, stretch, and direction they give the toddler.

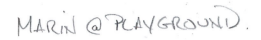

MARIN @ PLAYGROUND.

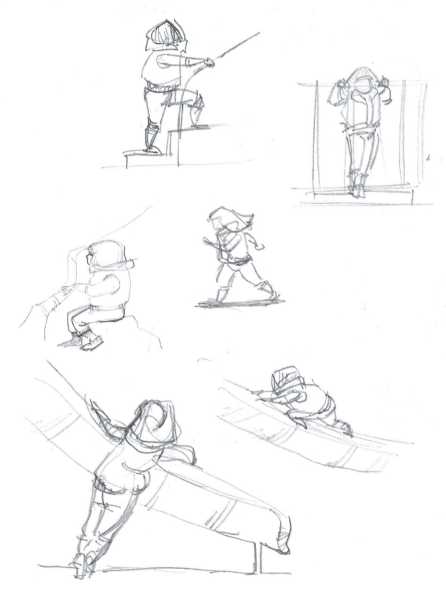

Here is my other daughter Marin, running around a playground. Her vest and pants make for easy shapes to define her proportions and forms. Playing with those shapes gives her dynamic story.

Relationships

Here we want to be aware of the interplay between two people. Again, as a human being you can watch the people around you in different emotional states and know what they are thinking or feeling. Instead of understanding the idea of one person, though, we now will grasp the main idea of two people. We are creating a new top to the pyramid. Rhythm is now the idea between two people instead of two ideas in the body. Pay attention to negative space again, for in a way it is its own character.

Before going outside with this challenge, I had two models pose nude at the same time so the clothing would not distract the students. This way there was concentration on the relationship of forces between the two models.

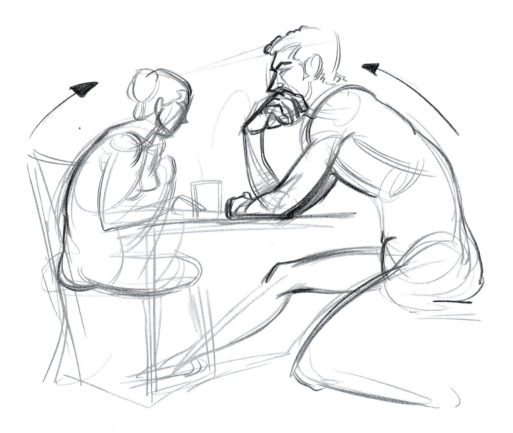

The story I see here is two people at a table who are leaning forward, but not in each other's directions spatially. She is reading to ignore him while he looks off into space, deep in thought. He covers his mouth to stop himself from speaking. There is the opportunity for focused discussion because of their forces sweeping forward. It is as though they had already spoken to one another and he is preparing to speak again.

Then I have students draw two clothed models. Here they have the opportunity – in a controlled setting – to see the couple's relationship.

In this drawing, my brother-in-law Chris's height difference automatically gives him visual superiority. He seems to be waiting for Ellen to get off the phone. Two ideas suggest this; one: his hands on his hips, and two: his relationship to her. Her phone conversation is a priority since she is looking away from him, yet she does stare at his shoes, recognizing his presence.

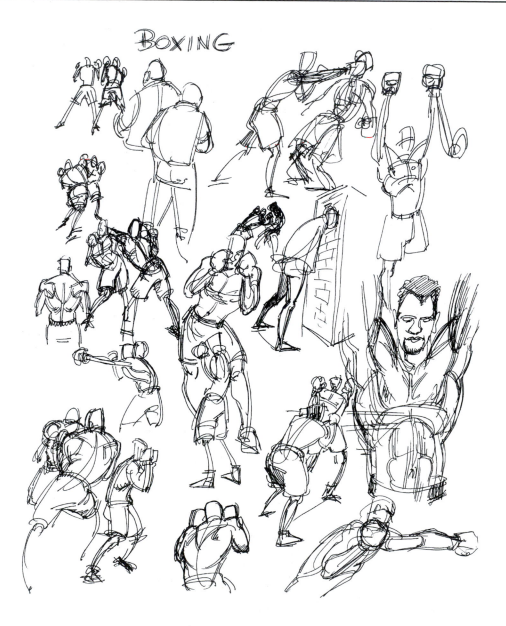

BOXING

This was a half-hour of watching a boxing match on TV. The contenders go through their own personal dance, caused by actions and reactions between the two. Like dancing cobras. All of the drawings are done in seconds. In the center of the page is a woman who was caught with drugs, and you can see her posture: leaning against the wall.

Try to set the scene that the moment you are observing takes place in. Act as if it is a play that you see before you. Be aware of the props around the characters. Let's go outside again.

The story of this drawing is about the boy assisting his father in seeing the object that holds his attention. You can see the direct connection between the arch of the father's back and the boy's extended arm.

Here there are many different types of relationships:

1. The photographers to their subjects.

2. The photographers to one another. See their similar posture.

3. The strange way that the down markers are a visual repetition of the photographers.

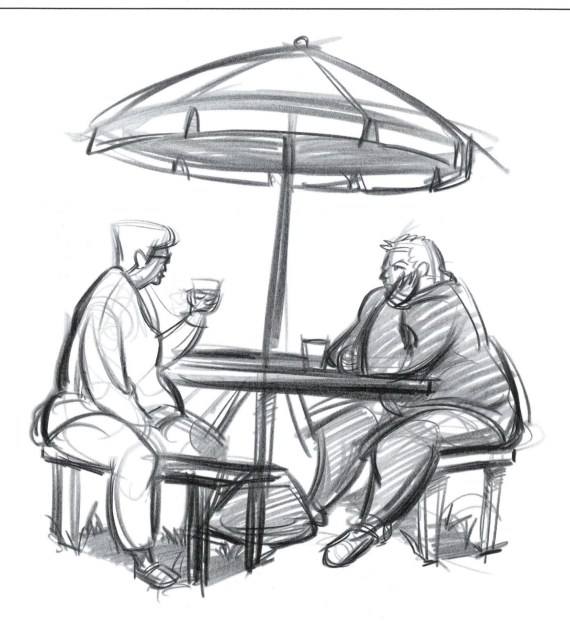

In the midst of a crazy birthday party, these two women found a moment to talk to one another under the protection of the umbrella. Their silhouettes tell you who is doing the talking and who is listening.

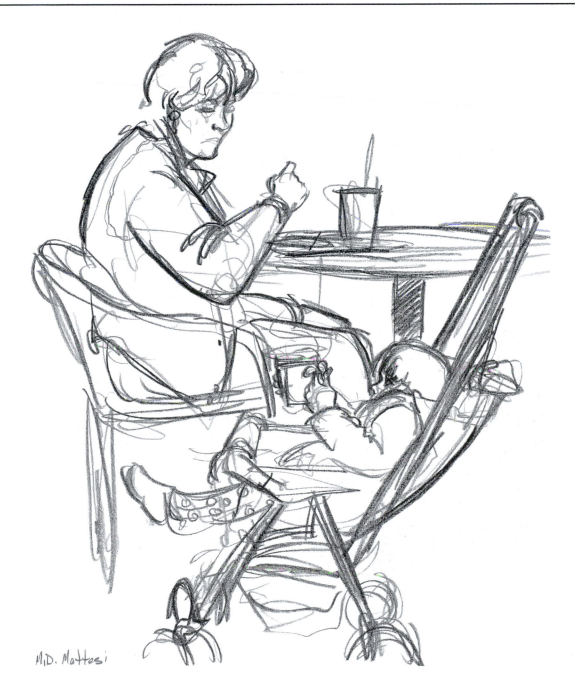

MiD. Mattesi

This is a close moment between a mother and her child. She observes the child handling its beverage. The child seems happy as it kicks and looks at its drink.

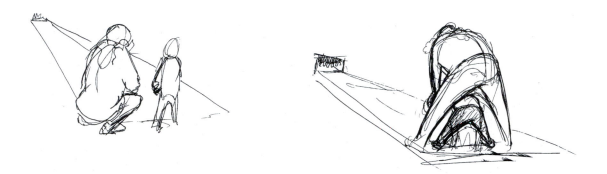

These are old drawings of mine that tell a great story. Here the mother helps the child bowl. I like the simplicity of the layout. It is like theater to me. Draw only what you need of the environment. The child in the first drawing feels like it is carrying a bowling ball.

Crowds

In drawing large numbers of people, see them as an entity. Look for the overall shape of the crowd. See what direction they move in as a whole, like a sea of force. Then break it down into the individuals. Again, this is a hierarchic approach. I have drawn thumbnails for you to see the compositions behind the concepts.

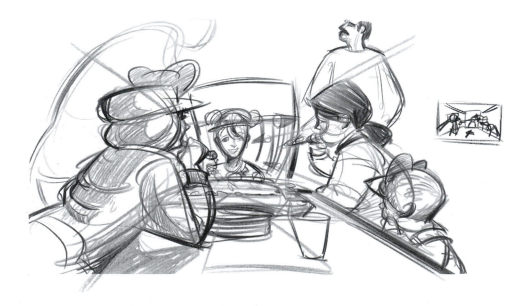

I enjoyed my location for this moment. The drawing feels as though it is about Charlie and the viewer. He is beyond all of the other children at the table and their distractions, yet is looking right at us. The arrows show how the children's gazes ultimately lead to Charlie. The thumbnail and blue directional lines show how the two triangles and the table point us towards Charlie in the center.

Putting a box around the next few images helps me compose the picture based on the story I want to tell. Here the crowd looks on at the performers. You can see the rough circle I drew around the musicians to assist me in the awareness of the story's focus. I also drew the closest man to us as a way of separating the crowd from the musicians. He gives us depth of field, too. Lastly, I grayed out the crowd so the performers would be brighter and draw your attention to them. Notice the multiple hands on the drummers to give a sense of speed.

Following the top of the people's heads, look at the arrows they create towards the fish. Here the figures are also darkened to focus on the fish.

This composition is encapsulated. Rich — framed between the umbrella and his audience — tells his tale. The curvature of the audience's backs, and direction of their heads, leads us to Rich.

This moment was captured one night at a Barnes and Noble that was holding a book signing. I drew this from the second floor. You can see the perspective by the way the people are stacked behind one another. The curve created by the people leads us up to the author and then past her to the separated individual. His attention to her brings us back. Look at the thumbnail for clarification of this idea.

See how I went after the moon shape created by the football team and how it directs us out to the field.

Texture of line is a great way to add more character and opinion to your work. Your drawing constitutes a visual medium, yet you have the power to make a viewer understand how a fabric feels or how heavy something is. You have the opportunity to experience more feelings as an artist because of this.

REPORTAGE POINTERS

1. Stay sensitive to the environment. Feel the temperature, hear the sounds and smell the aromas.

2. Look at people's humanity. Become aware of their stories.

3. See the stories in perspective.

4. Shapes help you draw faster. See shape in architecture and people.

5. Again, be aware of the clothes people wear.

Chapter 6
Animals

COMPARATIVE ANATOMY

Drawing animals on location can be more challenging than drawing people on location. The first reason is that it is harder to relate to them. They move faster and obviously in a different manner than us. How different? Not as different as you may think.

The way I was taught to understand animals was to compare them to us, bring them into our world. The first step in accomplishing this is in comparing our anatomies. Once you can relate an animal's anatomy to your own, you will understand their body language and in turn, their actions.

Ken Hultgren's book "The Art of Animal Drawing" is a great book on this subject. He touches upon force and covers a variety of animals. His drawings of horses are magnificent.

Here are some head drawings of Adrianne that I adore. Look at the expression in the top, right drawing and the different textures, which are what I was mainly after. So, man's best friend will be the first animal we compare to.

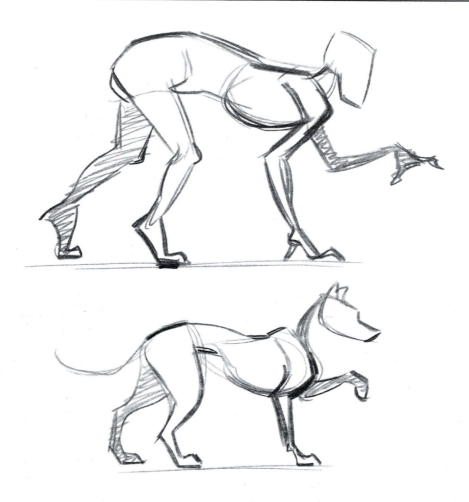

Let's look at a comparison between man and dog. This comparison works for all animals with paws but not hoofed. Here is a list of important ideas to see:

1. Look at how similar a dog's anatomy is to a man's on all fours. Look at the shoulders and elbows in both.

2. Notice the wrist. A dog cannot bend his paw upward like we can. This helps lock the leg when he is standing on it. His paw rests on the pad of our hand.

3. In the back leg, the dog walks on what would be the ball of our foot. The hip and knee relationship is similar.

For the most part, mammals fit in three major categories: plantigrade, digigrade, and unguligrade. It is not so important that you remember these terms, but remember the skeletal differences between the three so your comparison to us is correct.

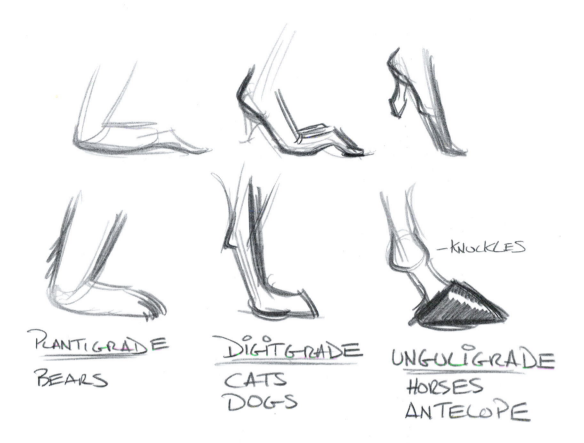

PLANTIGRADE
BEARS

DIGITGRADE
CATS
DOGS

—KNUCKLES

UNGULIGRADE
HORSES
ANTELOPE

These three examples show you how the three main categories of mammals' "hands" work relative to ours. Humans are plantigrades. We plant our whole foot down on the ground. Digigrade animals walk on the ball of their feet and hands. In the unguligrade example, the joint above the hoof is like our knuckles. These animals walk on the tips of their toes. The foot has the same changes in it as the hand does amongst the three examples.

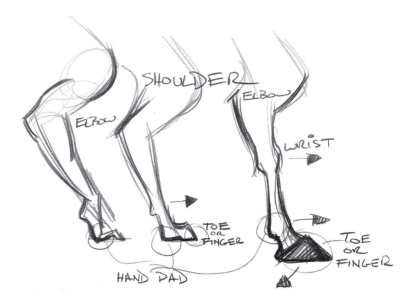

Look at the change in the hoofed animal versus the humans and dogs. The "wrist" is higher in the horse, which makes it seem as though it runs on its fingertips.

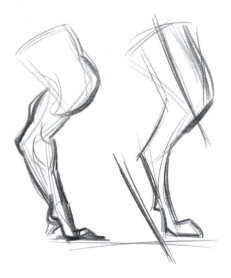

Looking closely at the limbs of both subjects, see where the shoulder, elbow, and wrist are in the dog. Of great importance is noticing how the angle of the shoulder is the same as the angle of the forearm. These parts of the dog's front and back legs stay parallel unless the dog is on its back and its limbs are not operating against gravity.

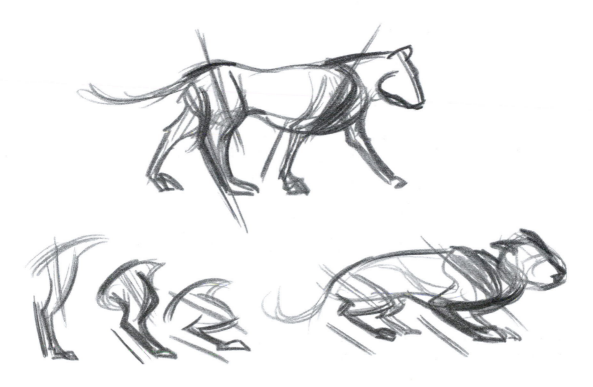

1. On this page, the drawings on the bottom left show how the back leg operates with this parallel concept through a large range of motion.

2. On the right is a drawing that shows how all four legs are working.

3. I created the drawing on top to show you the mechanics of a pawed animal. The cat's right side, in this case, has the legs in a closed scissor position where the left side is open. By doing this scissoring action to the one side of the body at a time, the animal walks. Another way this was explained to me was to think of the back leg kicking the front leg forward when it took a step.

As I have explained throughout the book, we want to understand the basic rhythm of four-legged animals first.

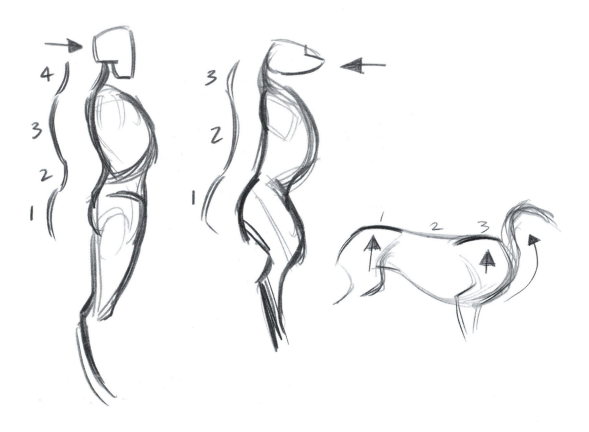

In this drawing, let's look at a comparison in rhythm.

1. The dog actually has one less change in direction of force. Reason being, the dog's ribcage is suspended like a bridge from the hips to the shoulders, or force 1 to force 3. His neck follows the sweep upward of the ribcage to raise the head.

2. Since we stand upright, our forces are different. Our ribcage is not suspended between two forces like the dog's. Our ribcage sits or is cradled in force 3 of the man.

3. See how this affects the force of the neck in both instances. Our neck projects our head forward where the dog's is projected back, or relative to how a dog actually walks: up away from the floor.

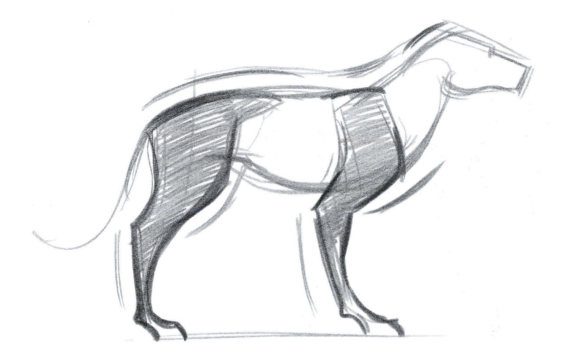

Here is an example of seeing shape in the dog. In Ken Hultgren's book "The Art of Animal Drawing," he makes a point of splitting animal bodies into parts. This helps to see how the major masses are creating the animals' figures and the different shapes of the parts.

Here I have shaded the fore and rear quarters for you to see the effective shapes and their relationship to the dog's body. When drawing animals, I see the major mass of the animal's body first, that is, its trunk, and then draw how the legs and their shape are affecting it.

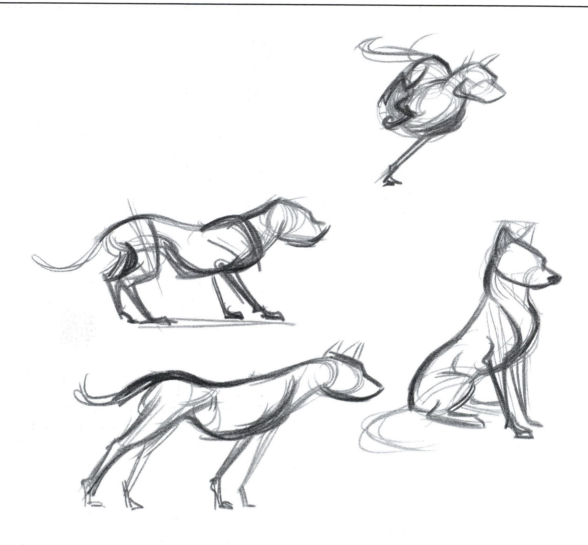

This page has small drawings with big ideas. Look at the dog's body as a whole. See the angles in the legs. See the shapes. Look at the rhythms. Feel the story.

I happen to have a dog named Adrianne. Why Adrianne? My in-laws have a dog named Rocky. Adrianne is great to observe. As I write this book, she has just become one year old. It's fun to see her thinking. Her body language is so similar to ours. It's strange how most expressive animals say the same things in the same ways. When she is happy, she jumps and wiggles around; when she is punished or sad, she droops her head down or sighs. Curious or alert, she becomes wide eyed and stands at attention. As every pet owner will agree, each animal has its own distinct personality, yet there are definite similarities in physical communication.

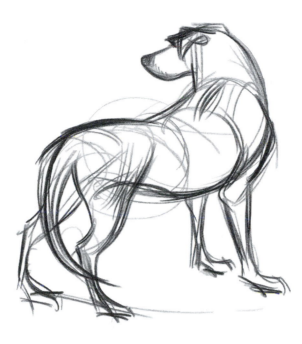

In this drawing of my dog, notice the overall shape of her body and how it already possesses rhythm from head to tail. See the flat angle of her back in relationship to the curve of her ribcage. I am happy with the shape of her neck in particular. The straight of the left to the curve of the right sweeps her face in the westward direction. See also how I wrapped her shoulder blade around her body to describe its form.

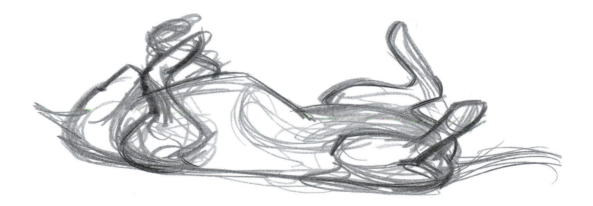

I enjoy the work and struggle involved here. I did a great deal of exploring to achieve my understanding of how Adrianne's anatomy operated while she lay on her back.

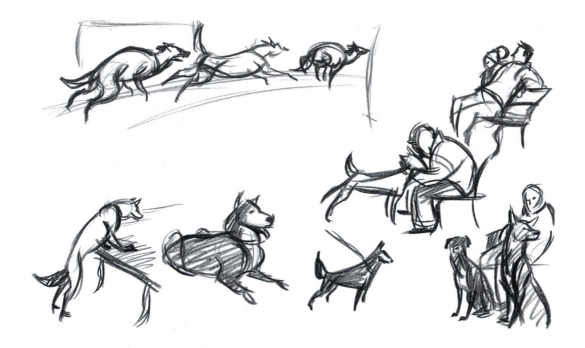

Here is a page of wonderful moments by Mike. Look at the different stories. I love the multiple images of the dog running. Notice the squash and stretch found here. I like the drawing on the bottom right where we see clear perspective from the two dogs sitting like pillars by their owner. Above that is a drawing of man and his best friend.

GOING TO THE ZOO

I had not been to the Bronx Zoo since I was in elementary school. Writing this book provoked me to return. It is so much fun to observe the animals. They come in so many different shapes, sizes, and colors, all because of how and where they live.

Simplistic seals

In going to the zoo, I suggest starting with simple animals first. Seals and sea lions are a great place to warm up. Their simple anatomy allows you to focus on their streamline, aquatic-designed bodies. Their simplicity allows you to focus on shape with force and form. All of the other animals in the zoo have basically the same shape body as the seal with different arms and legs.

Try to find the unique qualities of each animal, even within their own families. Look for their specific personalities and what they are experiencing when you are drawing them.

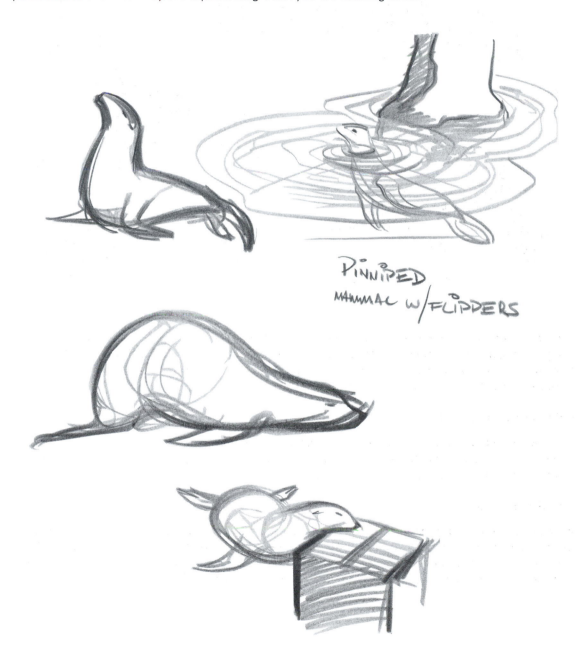

PINNIPED
MAMMAL W/FLIPPERS

So, here are the seals. Their forms are so flexible and fluid.

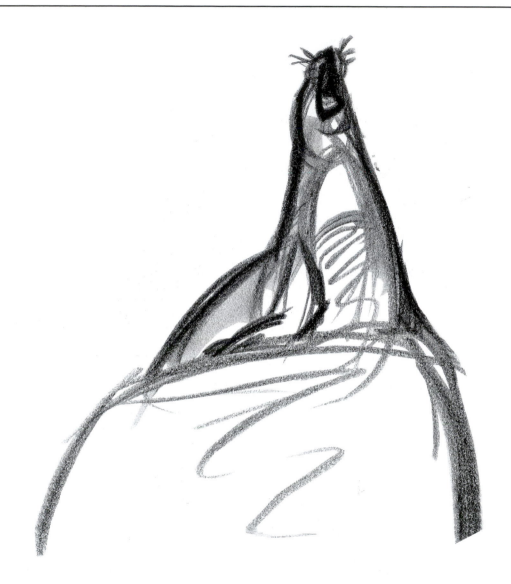

Keith pushes story here with the seal war cry. Look at the straight to curve and the feeling of stretch up to the head.

Use your experience with the seals to assist you in drawing the more complicated animals. See the shape of an animal's trunk and head first, then its legs. After drawing the seals, let's go through the zoo from the plantigrade to the unguligrade (or in easier terms, the bears and pawed animals to hoofed animals).

Plantigrade

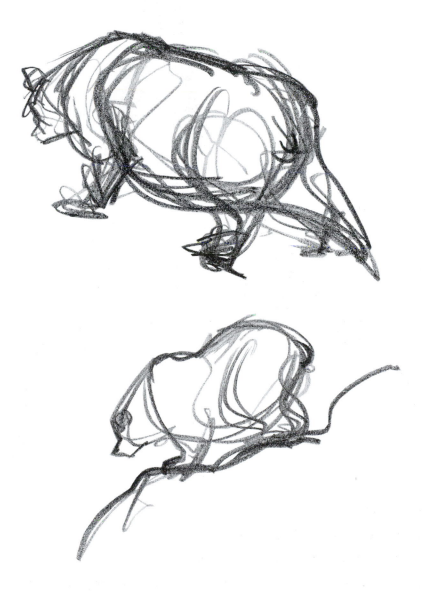

Here are some observations of black bears I saw in the Bronx Zoo. In the top drawing, I like the connectivity of the bear's belly to his right rear leg. The perspective the bear is in shows us his form wrapped around the previous idea. On the bottom, we see him making his way down a rock face. As I mentioned earlier in this chapter, you can see the divisions of the bear's body to help see shapes. You must make sure they all operate together in the end.

Here lies a polar bear on a hot August afternoon. See:

1. the shape of his arm,

2. the relationship of his back to his stomach,

3. the way his neck and head sweep out of his torso.

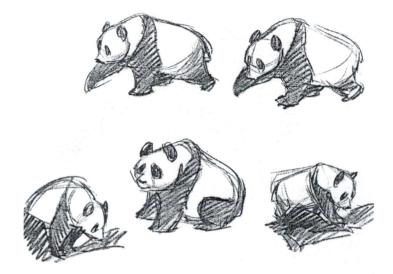

Here are some great panda drawings by Mike. The black shoulder mass helps define form and anatomy as we discussed earlier.

Digigrade

Here you can see that the shape of the lion was my approach. I love the size of his mane and head. With digigrade and unguligrade mammals, I make quick straight-line references of the legs for their angles.

The seated lion is also shape based with force and form in mind. I like the subtle hard moment captured in his right shoulder. The smaller drawing has force, form, and shape.

Unguligrade

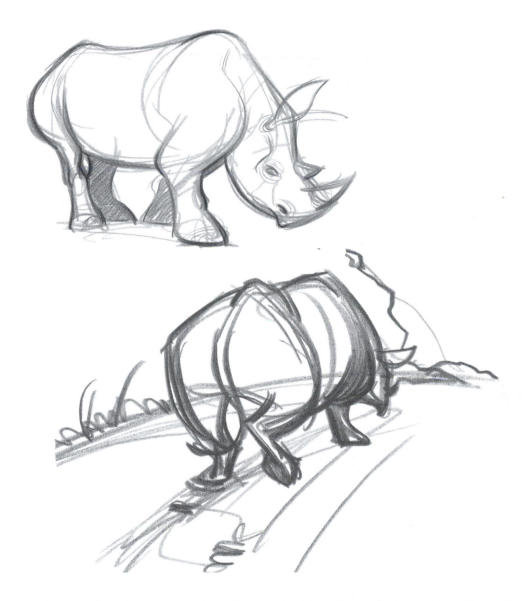

This has to be one of my favorite animals in the zoo. The black rhino is so powerful and beautiful. I loved watching it walk. The massive weight of it would push down into its feet as it walked, displacing the mud on the ground. Its long, heavy head seemed to hang from its shoulder girdle. Notice the difference in style in between the two drawings but they both have the theory of "force" within them.

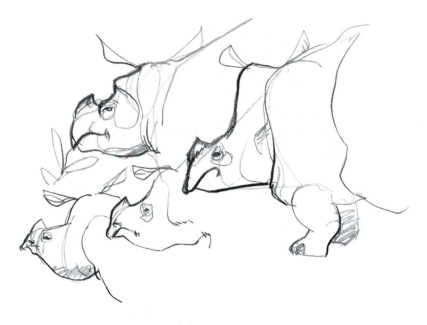

Here are examples of an Indian Rhino that I pushed some opinions upon. Look at the slight variations and see how much fun there is in personal design.

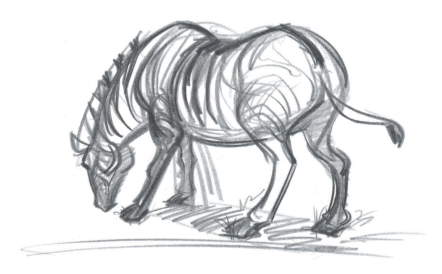

Grevy's zebras were one of the greatest challenges. This drawing was a product of many with poor results. First, I ignored the stripes to more clearly see the shape of its body. See the attention made to the wide hip region. The stripes could be added later to help emphasize form.

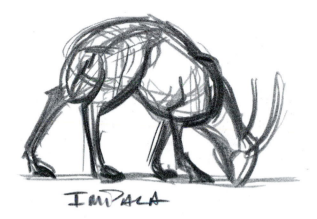

IMPALA

Look at the attention paid to the angles of the impala's legs and shoulder blade.

I feel that the most difficult of these animals to draw is the giraffe. Having done this with a still specimen before coming to the zoo, I had an advantage when it came to tackling this one. On the left is a more graphic representation. The drawing on the right has more fluidity and character.

This image was drawn at The Museum of Natural History. Before going to the zoo, I will often take students to the museum so they get an understanding of anatomy and shape.

This was also drawn at the museum as part of a lecture. The top left is the drawing and everything around it is an explanation of the thoughts within it. You can see simplifications of force and shape. Notice in the silhouette, the breakdown of straight to curve in this moose.

Primates

The Bronx Zoo has a brand new exhibit called The Congo. The design of the exhibit allows you to get within inches of exotic and interesting creatures from that region of the world. Primates are the focal point of the exhibit.

Watching primates is fascinating because of their similarity to us. It is easier to relate to and understand them because of this. Look at their body language and facial expressions.

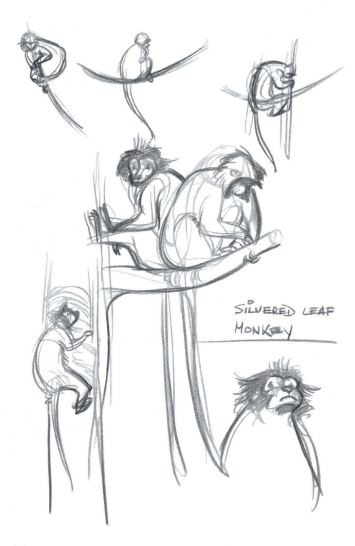

SILVERED LEAF
MONKEY

The drawings around the perimeter are the most fun for me. I enjoy seeing the shapes of their body's forces. Look at how the shape tells us about the effort being made. Their long tails help them balance up in the trees.

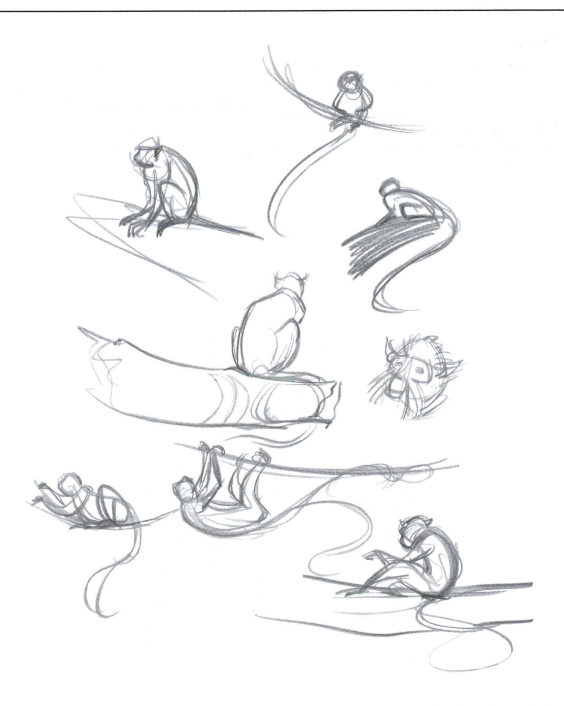

I believe these drawings are of the Red-Tailed Monkey. They were more active than the Silver-Leafed. Look at how their tales are a continuation of the rhythm found in their backs.

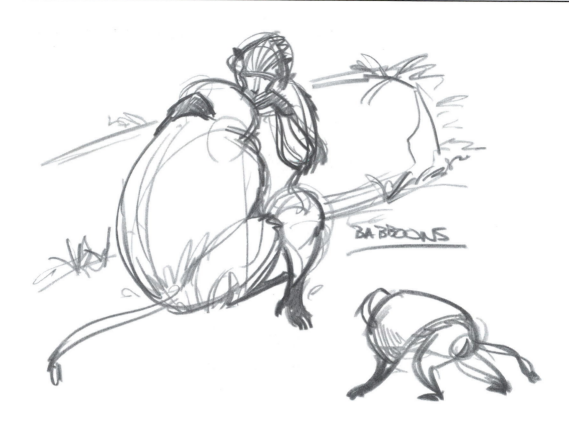

Here are some baboons cleaning one another. Simplicity of shape from force and form once again convey clear ideas quickly. The baboon walking has a great shape on his back from the extra fur he has. Look at how that shape leads into his arm.

The Congo has a special exhibit of the western lowland gorillas. It is a glass tunnel that allows you to get within inches of these animals.

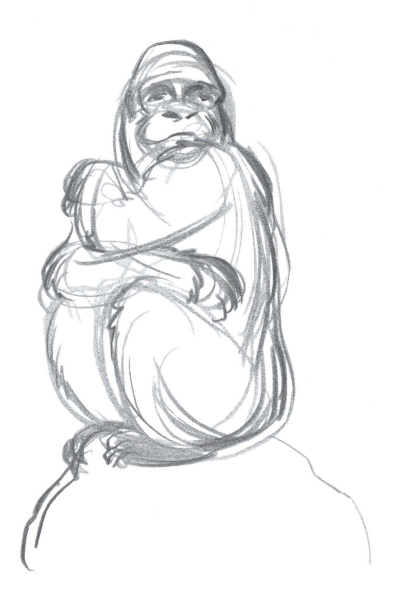

This western lowland gorilla was about two feet away from me. Incredible. Look at how human the forces of her body are.

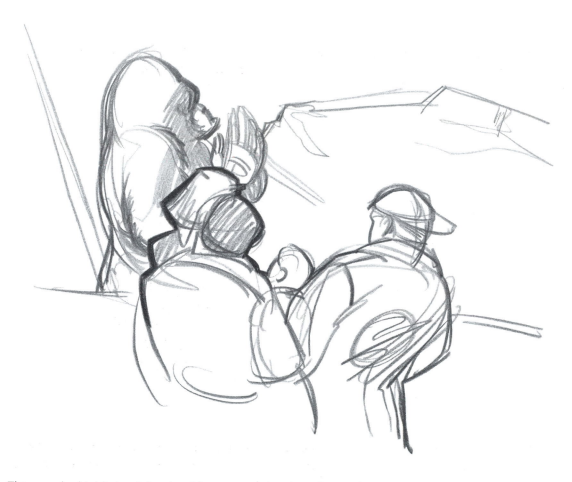

This was the highlight of the day. The woman closest to the gorilla put her palm on the glass that separates us from the animals. So the male gorilla lifted his hand and slapped it on the glass. When he did this, the glass tunnels echoed with the power and weight of his hand. Awesome.

Birds

Last but not least are birds. Here again, we want to compare our anatomy to theirs. In so doing, you will better understand what it would be like to take flight and soar amongst the clouds. You would reach forward with your fingertips and sweep your arms down to your sides, bringing your elbows in and bending your wrists.

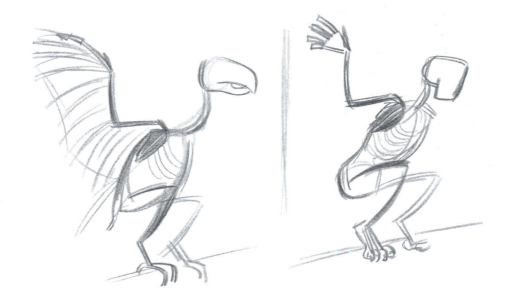

Look at the similarity between our arm and the bird's. Look at how his extended feathers would be our fingers. The rest of our feathers would drape down from our arms. The upward peak of the wing is our wrist. There is barely any difference in the legs either.

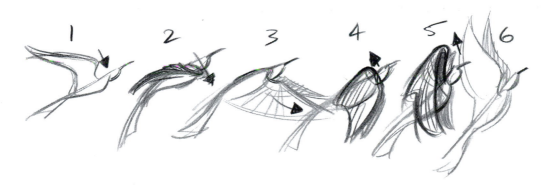

See how important the wrist is in a bird's flight. In 2 the "wrist" is the leading edge of force, driving the wing downward. In 4 the "wrist" drives the wing upward.

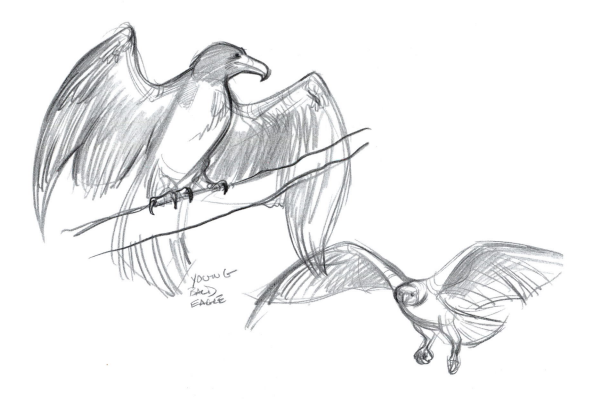

I have used this drawing of a young bald eagle to show you our anatomy in this pose. Imagine our skeleton in the other bird.

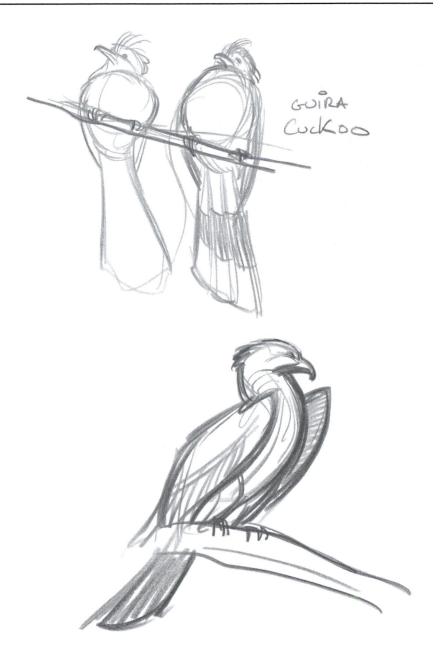

GUIRA
CUCKOO

I end this chapter with these two Guira Cuckoos. I like the squash and stretch we see in their bodies. Their relationship makes this visual difference possible.

Enjoy the world of animals. See our similarities and differences. They also have great stories to uncover. Through understanding animals, we can learn more about our selves. You will uncover new mannerisms and personalities that you can use for your creative work.

ANIMAL POINTERS

1. Start with seals and learn their fluid, simple shapes. Take this shape to the more complex animals.

2. Get the rhythms of the animals down with forceful shape. Then you can use them as a reference point to add more information.

3. See the character of the particular animals. Compare them to people.

4. Learn the different anatomical structures of their limbs.

Closing

I believe that great drawing starts with an understanding of the fundamentals. For me, one of those fundamentals is force. Through this understanding, one is freed up to start forming opinions.

In the end, you want to bring as much of yourself as possible to your work. Have an opinion and fight mediocrity. Learn to understand what you find interesting. That will be where your individuality lies.

"All the knowledge I possess everyone else can acquire, but my heart is all my own."
Goethe

Every day, I take a moment and realize the beauty of the life around me. Drawing is a miraculous vehicle with which to do this. Let it be your window to awareness of the remarkable world around you. In turn, this will revolutionize the world inside of you.

I hope that you have enjoyed this journey with me, and that you're leaving it with something new and inspiring. Keep drawing!

Visit me at www.drawingforce.com or www.enterartacad.com I would love to hear from you.

RECOMMENDED READING

The Drawings of Heinrich Kley
Dean Cornwell, The Dean of Illustrators
J.C. Leyendecker
The Art of Hellboy or any of Mike Mignola's comics
Any Disney Book
Claire Wendling's Drawers
Frezatto Sketchbook
Any Frank Frazetta book
John Singer Sargent Drawings

Azpiri Sketchbook

Bernie Wrightson's *A Look Back*

Carlos Meglia comics

The Art of Richard MacDonald

George Bridgeman's *Complete Guide to Drawing from Life*

Charles Dana Gibson's *The Gibson Girl and Her America*

Elliot Goldfinger's *Human Anatomy for Artists*

GLOSSARY

Applied force	A past directional force transferring itself to the next directional force.
Assymetrical	Not symmetrical or not balanced; having contrast.
Contrapposto	The oblique balance between the torso and the hips
Directional force	A force in the body created by the pull of gravity on human anatomy.
Force	Any push or pull exerted on an organic form because of gravity and the object's posture relative to gravity.
Forceful shape	An asymmetrical shape that moves force from one location to the next in whatever organic form it is describing.
Hierarchy	The concept of thinking from a big idea to a small one. When it comes to drawing force that means going after the largest rhythms in a pose before the smaller ones.
Leading edge	The edge of a form that leads in the direction of the action it is taking.
Overlap	Where one line stops another, causing the illusion of one form being in front of another.
Rhythm	The beautiful interplay helps at least two directional forces in the body that stay in balance or creates equilibrium against the force of gravity. Rhythm exists in all living things.
Roller coaster of rhythm	This term is used to describe rhythm in four-dimensional space. This causes rhythm to not only bounce from side to side, but to travel through and around the organic object being drawn.
Silhouette	The filled-in shape created by the outline of an object.
Surface line	Line that lands on the surface of the subject to help describe its forceful volumes.
Tangent	The moment where two lines describing two forms touch each other. This causes equality in space of both forms, which in turn takes away the opportunity for page depth.
Torque	Twisting force mostly found between the ribcage and hips.

Index